A HISTORY OF
LITTLE
HAVANA

A HISTORY OF

LITTLE

HAVANA

**GUILLERMO J. GRENIER
& CORINNA J. MOEBIUS**

THE
History
PRESS

Published by The History Press
Charleston, SC 29403
www.historypress.net

First published 2015

Manufactured in the United States

ISBN 978.1.62619.647.6

Library of Congress Control Number: 2014953441

Notice: The information in this book is true and complete to the best of our knowledge. It is offered without guarantee on the part of the author or The History Press. The author and The History Press disclaim all liability in connection with the use of this book.

Guillermo Grenier dedicates this book to his mother, Nelida Mendez Grenier, and to the memory of his father, Guillermo Juan Grenier. They lovingly brought him through Little Havana over five decades ago. It was the portal that led to the rest of his life. It has been a good life thanks to their unconditional support, love and understanding.

———•———

Corinna Moebius dedicates this book to the memory of Eduardo "Eddy" Leandro Campa, the late East Little Havana poet who wrote not far from where she lives and writes now, in East Little Havana's beloved barrio:

I will anxiously wait to see the light of dawn,
of every dawn.
That the smell of life should excite me
when it brushes against my bones
and my gratitude, that of a banished man,
always responds to its call
All of us, all of us are in Memorial Park
—Eddy Campa

Contents

Acknowledgements

We want to thank a great many people for making this book possible.
First, we would like to thank Alina Mencio from the City of Miami's
Planning and Zoning Department for graciously agreeing to prepare our
map of Little Havana.

For our photos, we are indebted to the following individuals and
organizations: Laura and Fernando Gonzalez from Vecinos en Acción;
Sylvia Vieta and Teresa Callava of the Kiwanis Club of Little Havana;
Hugo Miranda; Irela Roldan of DAF Studio; Tony Mendoza; Rita Blanco
of El Dorado Furniture; Melanie Masterson of Eleven:11 Entertainment,
Inc.; and "Infrogmation," who posted his photo on Wikipedia.

In addition, we are grateful to Maria R. Estorino Dooling and Meiyolet
Mendez of the Cuban Heritage Collection at the University of Miami
Libraries, Dawn Hugh and Ashley Trujillo of the HistoryMiami archives and
the kind staff of the Miami Senior High library for their assistance in letting
us use photos from their respective archives. We also want to thank Eleanor
Guldbeck at the Miami-Dade Public Library's main branch for her help.

It is the personal stories, however, that have made the most difference in the
writing of this book, many of them not documented elsewhere. We thank all
who took the time to share these stories with us. Dr. Paul George, Ron Sadaka
and Candy Koukoris helped us understand what the neighborhood was like
before it was called Little Havana. Raissa and Raisa Fernandez, Juan Coro,
Tony Mendoza, the Hernandez family (Peter, Guillermina, Angel and Angel
Jr.), Ronilda Caridad Woodrich, Marta Laura Zayas, Adalberto Moreno, Maria
Gonzalez-Gil and Rene Janero shared fascinating tales about Little Havana in

the early years of exile arrival. Many local leaders were kind to help us grasp the changes that have taken place with regards to planning, development (including the Latin Quarter) and tourism, particularly Commissioner Willy Gort, Jose Casanova, Pablo Canton, Luis Cuervo, Jose Fernandez, Carole Ann Taylor, Rogelio Madan, Bill Fuller, Eloy Aparicio and Obdulio Piedra.

Our book would not be complete were we not listening to the stories of those whose voices are too often left out in representations of Little Havana. For sharing these stories, we are deeply grateful to Hugo and Sonia Miranda, Brenda Betancourt, Ezequiel Torres, Alvaro Alvarez, Fernando and Laura Gonzalez, Ana Mendoza, Juan Quiñones and Cristobal Mena.

We thank Luis Sanchez, Pedro Bello and Sandy Cobas in particular for describing Little Havana's cigar manufacturing industry and dynamics. Many people contributed to our understanding about Little Havana's arts scene and, at the same time, the experiences of later-arriving Cubans and Generation ñ, including Adalberto Delgado, Brigid Baker, Carlos Suarez de Jesus, Ralph de la Portilla, Steve Roitstein, Luis Palomo, E.R., Luis Molina, Mario Almoza, Roberto Ramos, Atomik and Boris Alvarez. We are grateful for their time.

We also thank Fabiana Brunetta for the tireless editorial assistance she provided in honing down an overly researched manuscript into an accessible story of a vibrant neighborhood. She saved the reader a great deal of frustration and saved us from considerable embarrassment.

We also want to give a shout out to the journalists who have delved beyond the stereotypes of this neighborhood to give a richer picture of what is happening here.

We are grateful to the efficient professionals at The History Press for their guidance and support throughout. We are particularly thankful to Alyssa Pierce and Hilary Parrish for their attentive shepherding of the project.

This is Corinna Moebius's first book, so she would like to thank her parents, Miriam and John Jenkins and Bill Moebius, for their love and support, as well as her grandmother Jeanne Thune, who has encouraged her every step of the way. She is full of gratitude to Lionel McKoy for his tireless support during the research and writing of this book.

Corinna would also like to add how much she has been fueled by the energy and spirit of Little Havana's dedicated community leaders, as well as and including her neighbors who give this place its soul. We apologize for the many we do not name but who indirectly helped make this book possible; we also apologize for not having the room in this book to account for other important individuals, businesses and organizations that have made Little Havana what it is.

Chapter 1

An Imagined Community, a Living Community

For me, Little Havana is a sanctuary. A safe place to be Cuban. Where all Cubans come live. To feel they're alive. And sometimes to die.
—*Miami Cuban American born in Cuba*

It's "El Barrio de Barrios," home away from home. Part Macondo, part Central Station of Brasil *(yeah, the movie), with no boundaries, and everyone here is a* paisa *or* primo *regardless of where you are from. Whether it's where your American dream begins or where it ends, it is here where many have come to really open our eyes.*
—*Hugo Miranda, Latino resident of East Little Havana*

When we set out to write this book about Little Havana, we wanted to bring together two narratives—two sides to a story, the story we share here. Guillermo, a professor and sociologist, wanted to show the ways Little Havana is imagined and how it serves as a stage for Cuban American politics and identity. Corinna, a cultural anthropologist who lives in Little Havana and gives walking tours of the neighborhood, wanted to write about the lived experiences of locals then and now. This book will give you both "Little Havanas," since both the imagined place and the lived place shape each other. We will show some of the ways this mutual shaping has occurred over the last five decades.

The shifting needs of the city of Miami and its urban planning strategies for Little Havana may fix it as a planning district or demarcate it as a

development initiative. But these boundaries are a product of rational imaginations that ultimately fail to truly contain the meaning of Little Havana. In the lived experience of millions of Cubans in the diaspora and on the island and an increasing number of Central Americans and others connected to this imagined space, Little Havana is less a geography than a state of mind. Little Havana is a place where Cubans and other Latinos have attempted to re-create a feeling of a place that exists mostly in memory: a liminal place—neither here nor there. In the United States but not of the United States. Referring to Cuba and other homelands but far away from those realities as well.

It is also a tangible place where everyday people are walking to laundromats, cafeterias and bodegas and talking (usually in Spanish) with neighbors about the new business near 10th Avenue, the person who nearly got run over on Calle Ocho, the landlord who just raised his rents, the band that is performing Saturday night. Little Havana lives.

Little Havana is not an official municipal entity. It is a community established by the memories and social relations of individuals living within a specific geographic space, a relatively new creation in a relatively new metropolitan area. Its location just west of Miami's downtown places it in a strategic position for settlement and expansion. It is a product of geopolitical social forces promoting migration from Latin American countries—particularly Cuba, a country with a long history of relations with the United States and South Florida—into an area with no established history of immigration.

Little Havana is part of the city of Miami, the largest of the thirty-six municipalities in Miami-Dade County. Its northern border leans against the Miami River and approaches Overtown, a predominantly African American community—one of the oldest and now poorest neighborhoods in the county. South of the neighborhood and its famous artery Calle Ocho are two middle- to upper-class residential suburbs, the Roads and Shenandoah, although some people consider both to be part of Little Havana. To the west lies the wealthy residential neighborhood of Coral Gables and to the east the increasingly upscale downtown district and the financial and residential high-rises of Brickell Avenue facing Biscayne Bay.

The key moment in the development of the city of Miami neighborhood now known as Little Havana was January 1, 1959. The date marked the triumph of the Cuban revolution—*El Triunfo de la Revolucion*—which drove hundreds of thousands of Cubans into a diasporic existence. Many settled in South Florida and most of these in a small area in the southwest region of the city of Miami. The early Cubans who arrived in the 1960s, in a city that

was not long from its frontier days, are today found in every municipality in South Florida. Indeed, the emergence of Little Havana was an expansion of the western frontier of an atypical U.S. city.

Little Havana is a Cuban/Latino extension of the edge-of-the-continent settlement that is Miami: the Magic City. From its inception, Miami was a frontier city with a twist. Unlike other frontier cities, it was not a waypoint to anywhere else or from which expeditions were launched to expand into new regions. Miami was incorporated late in the game compared to other East Coast cities—in 1896, soon after Henry Flagler completed a railroad linking it to northern Florida and the rest of the East Coast. It was, literally, the end of the line. It was not a stop along a well-traveled trade route. It was not an industrial nexus like other well-established northern cities such as Chicago, Cincinnati or Pittsburgh. And although it was a coastal settlement, its emerging port facilities could not compete with New Orleans or the port cities of the East Coast.

Like many frontier cities, Miami always has had a large transient population and a high proportion of first-generation residents. Until very recently, it lacked a consolidated socio-political structure and a traditional core of well-established elites, traditional families or power brokers whose vision drives civic concerns. If this is a weakness, its strength is that Miami always has welcomed newcomers, particularly if they were white and possessed money, dreams and panache.

Miami was built on the vision of eccentric speculators. In the 1880s, Henry Flagler, millionaire partner of John D. Rockefeller, moved to Palm Beach for his health and found a new career as a railroad and real estate magnate. A decade later, he was persuaded to extend his railroad to Miami by Julia Tuttle, an unconventional widow who had left society life in Cleveland, Ohio, to forge a new home for her family. According to popular legend, when an unprecedented cold winter in 1895 destroyed most of the crops upstate, she seized the opportunity to illustrate the market potential of the warmer climate of South Florida by sending Flagler an orange blossom. While the real story is a bit more complex, it was Tuttle's tenacity, coupled with an offer of free real estate, that convinced Flagler to extend his railroad southward, providing the necessary transportation link for Miami's emerging tourist and citrus industries.

It is hard to imagine Little Havana, one of the city of Miami's oldest suburbs, not being a focus of Latino cultural, economic, political and social life. There was a time when this same geography held a different meaning and projected a different fate. As an imagined community, it is primarily a

product of the collective imagination of Cuban Americans, and it needed Cuban Americans to exist.

The geography of Little Havana existed before the Cubans imbued it with its present essence, much like Mulberry Street existed before Italians arrived in New York City's Little Italy and Pell Street existed before the multiple Chinese migrations created Chinatown. Historian Dr. Paul George has written about the early history of South Florida. Our description of the pre-1959 history of the area known as Little Havana owes much to his work. During its early history, the area now known as Little Havana was composed of homesteads of the early settlers. In the 1890s, the Belchers owned 140 acres around what is now Calle Ocho between 17th and 22nd Avenues. Later, Captain Charles Rose owned 160 acres around Coral Way and 22nd Avenue.

The outlines of the present geography of Little Havana were plotted into the city of Miami's cartography in the 1920s, when the area was included within the city limits as part of the region's nascent urban sprawl. The present Little Havana was carved from two adjacent suburban neighborhoods: Shenandoah and Riverside. Riverside, developed by William Brickell, one of the founders of the city of Miami, stretched as a long north–south rectangle from 8th Street to the Miami River along 12th Avenue on the east and 17th Avenue on the west. This area is now within the northern regions of today's Little Havana, known as East Little Havana, and was a predominantly working-class Jewish neighborhood. It was an upper-middle-class neighborhood growing with the city, home to the first junior high school in Miami; Flagler Street, its main east–west drag, was the bustling commercial artery of Miami.

In the 1950s, the area began to deteriorate. The deterioration served as the foundation for its metamorphosis into the cultural heart of Cuban/Latino Miami. By the time Cubans came in 1959, the area was already known for its low rents and spotty infrastructure. Cubans could afford to live there while being close to downtown Miami, the main source of employment as well as the location of the refugee service agencies facilitating their integration into U.S. society.

The neighborhood of Shenandoah, to the south of Riverside, dates to the 1930s, and although it is also a vernacular creation of tradition and relations (not an official municipal entity), it maintains a strong identity today. At the southern border of Little Havana, the area is characterized by large single-family homes and by the existence of various city and county facilities that bear Shenandoah's name. These include Shenandoah Park and the Shenandoah Elementary and Middle Schools, as well as the Shenandoah

Branch of the Miami-Dade Public Library System. The Miami Shenandoah Neighborhood Association establishes its boundaries to the south of Little Havana—Southwest 12th Street on the north, 22nd Street (Coral Way) on the south and 16th and 22nd Avenues on the east and west, respectively. Developers named the area after the scenic Virginia valley because, at its inception, the homes were being built among piney woods and farmland.

As these neighborhoods were developing, Southwest 8th Street became part of the main east–west artery connecting southeastern Florida to the Gulf Coast. The Tamiami Trail, as the road is called, was built between 1915 and 1928 and became a prime driver of tourism into Miami and the entire southeastern region of Florida. Visitors from all over the state could now come to Miami by car on a modern road, and 8th Street was the gateway to the city. Small hotels and seasonal apartment houses soon sprang up, as did small businesses.

As the gateway from the west, the southwest quadrant of Miami became prime real estate. The former home of Miami's first mayor, John Reilly, is in Shenandoah. Today it is the St. Peter and Paul Eastern Orthodox Church. Richard Nixon and Bebe Raboso would attend church there in the 1970s. Nearby is Conch Hill, on the corner of 11th Avenue and 11th Street, a nineteen-foot-high hillock—a mountain by Miami standards. Along Southwest 11th Street is the eclectic display of homes built before the Cubans in Mission, Mediterranean Revival, Deco or Florida Bungalow styles. "The buildings remain the same, the business remains the same—the only thing that changes is the ethnicity," says Dr. Paul George.

Starting in the 1920s, a Jewish population dominated life in the geography today known as Little Havana. The luminaries of the Miami Jewish community lived in the area. Isador Cohen, allegedly the first Jewish resident of Miami, and his wife, Ida, lived there. They were community leaders, the forces behind the creation of the Miami Jewish Home and Hospital for the Aged. Max Orovitz, one of the founders of Mount Sinai Hospital, also called Shenandoah home. The first synagogue was built on 3rd Street between 15th and 16th Avenues. In the 1930s, the Jewish community dominated the two neighborhoods of Shenandoah and Riverside. By the 1950s, the stretch of 8th Street between 12th and 27th Avenues had become a major Jewish retail area. A kosher meat market, Stahl's, used to stand where today we find a Cuban grocery store at 8th Street and 13th Avenue.

Cubans lived in Miami before 1959. Maria Cristina Garcia, in her book *Havana U.S.A.*, suggests that there were as many as thirty thousand Cubans in Miami to greet the post-1959 arrivals. Louis Perez, in *On Becoming Cuban*,

estimates twenty thousand. Other old-timers suggest that around ten thousand were living in today's Little Havana area. All of these estimates seem high, given that the city of Miami, using census data, estimates that only thirty thousand Latinos lived in the entire county in 1955. But it is true that Miami was a very familiar place to middle-class Cubans. Cubans, if they could afford it, would come to Miami and feel at home. They arrived as visitors by the hundreds of thousands: forty thousand annually during the 1940s and at a fifty-thousand-a-year clip during the 1950s.

But we would stray too far from the topic of this volume if we detailed the deep and lengthy relationship between Cubans and Miami. What we need to emphasize now is that when Cubans before 1959 talked about Miami as an extension of Havana, they did not refer to the geography we know today as Little Havana. They spoke of "Biscayne Boulevard [being] an extension of Havana's Prado." As Luis Perez notes (quoting Jose Monton Sotolongo), "To go to Miami is so common, as if to go to a city in Cuba itself…To speak here of Flagler Street, Biscayne Boulevard, Lincoln Road, Miami Beach, the Seminoles, the pools and the area of Coral Gables, for example, is to talk about our own places." So if you wanted to find some Cuban music or Cuban food in Miami, you could, but not along the Tamiami Trail (now called Calle Ocho).

The first and oldest Cuban neighborhood in Miami was in the downtown area at 1st Avenue and Northeast 2nd Street. There the early émigrés, many of whom fled from the dictatorship of Fulgencio Batista in the 1950s, established pawnshops, bookstores, bars and souvenir shops clustered around the Gesu Roman Catholic Church on 2nd Street and near the Cuban Consulate. The early Cuban settlers gathered at the "Torch of Freedom" in Bayfront Park to express their discontent with the political situation in Cuba. This symbolic gathering place used to be the preferred spot for protests and demonstration among Cubans in Miami before the pantheon of monuments and memorials sprang up in Little Havana. Many were buried in Woodlawn Park Cemetery near today's Little Havana. There, among the resting places of Miami's American pioneers, is the grave of former Cuban president Carlos Prio Socarras marked by a Cuban flag. Another Cuban ex-president, General Gerardo Machado, who escaped from the island in 1933 with a few friends and seven bags of gold, lies in a marble crypt nearby.

Little Havana does not have an official or permanent fixed boundary that defines its geographic dimensions. The area has existed with loose boundaries based largely on cultural perception. Dr. Paul George establishes the largest area: from the Miami River on the north to U.S. 1 on the south

and from 37th Avenue on the west to the eastern bend of the river and I-95 on the east. The Planning, Building and Zoning Departments of the City of Miami have established variable boundaries for the neighborhood over the last four decades. The broadest includes part of the Shenandoah neighborhood to the south, but it never stretches to the west beyond 27th Avenue. For Rogelio Madan, a former planner for the city who wrote his master's thesis as part of a redevelopment plan for the area, Little Havana is composed of multiple neighborhoods: "Shenandoah is part of Little Havana. The north part is called Little Managua." He defines it based on the always-shifting demographic characteristics of the area: "[There is] a constant flow of people coming in and then moving out to the suburbs."

In a study on the perceptions of what geographic area encompasses Little Havana, Hilton Cordoba, Russell Ivy and Maria Fadiman surveyed 153 respondents on the boundaries they would establish for the neighborhood. They discovered interesting patterns dependent on where the respondents lived (inside or outside of the Little Havana area), the age of respondents

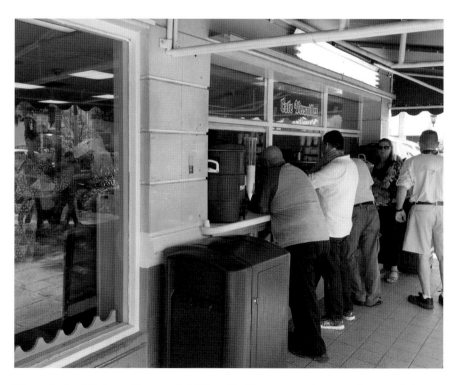

The *ventanita* of Cuban exile stronghold Versailles Restaurant, where people are ordering Cuban coffee, 2014. *Corinna Moebius, photographer.*

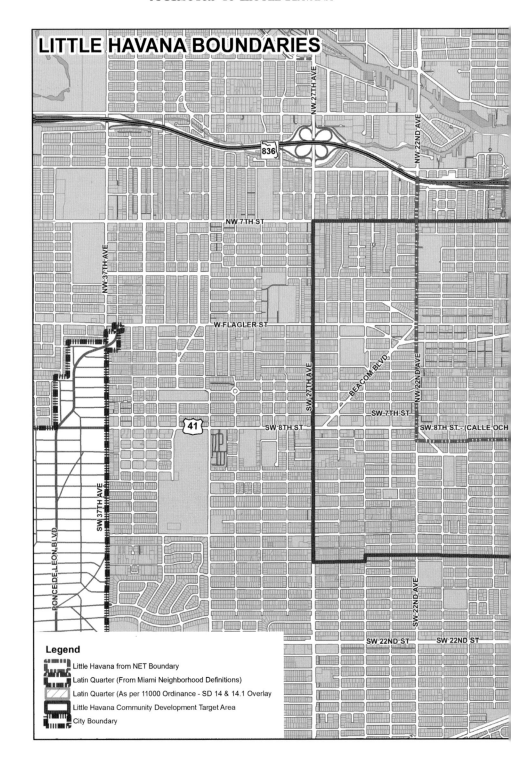

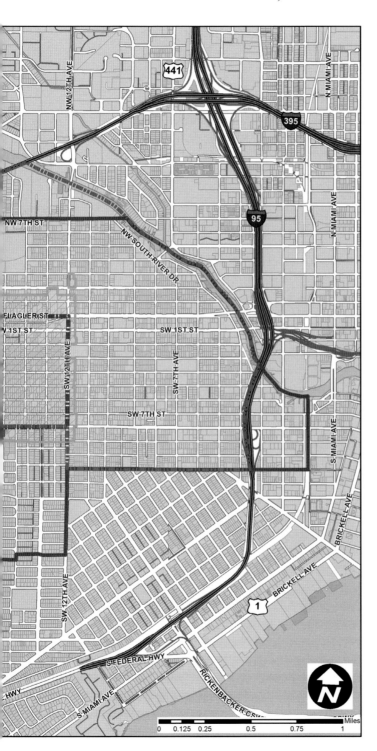

A map of Little Havana showing various boundaries. *Prepared in 2014 by Alina Mencio, City of Miami's Planning and Zoning Department.*

and length of residency in Miami. The longer a respondent had resided in the area, or in Miami outside the area, the smaller Little Havana became. The meaning of Little Havana is not a matter of geography but a product of experience and imagination. Little Havana is a state of mind.

So how do we define Little Havana? We interviewed dozens of decision makers and residents and found, not surprisingly, that while the boundaries of Little Havana are fuzzy, its core is not: 8th Street—Calle Ocho—is the heart of Little Havana, although residents who live close to Flagler Street might challenge that popular notion. And not all of Calle Ocho is part of Little Havana. The famous Versailles Restaurant, for example, although on 8th Street, is farther west than what most people consider the geographic boundary of Little Havana. Nevertheless, Versailles is promoted in numerous tourist and media reports as a Little Havana institution and the "heart" of the Cuban community. The founder of the Facebook group Friends of Little Havana passionately defends the area from Southwest 27th to 37th Avenues as part of the neighborhood.

For our purposes, we offer an operational definition of Little Havana as an area with the boundaries on the north at the Miami River, east by Southwest 4th Avenue, south by Southwest 9th Street and west by 27th Avenue. We speak of Little Havana as the area demarcated by these boundaries with the acknowledgement that the social, political and economic dynamics of Little Havana are not formally bounded by these or any other borders. It has a heart, and the heart supplies life to much of what it means to be Cuban in Miami and, indeed, in the United States.

Little Havana has a reputation as a place where collective action occurs, in the form of both cultural celebrations and protests. Public events provide a means through which neighborhood residents and others come together to celebrate aspects of their culture and, at the same time, participate in civic life. In Little Havana, these have included events like the annual Calle Ocho Festival organized by the Kiwanis Club of Little Havana in March for nearly forty years, the Nicaraguan community's Griteria celebrations and the arts and culture festival Viernes Culturales (Cultural Fridays) every last Friday of the month for the past decade.

Although Little Havana was once a Cuban ethnic enclave, the ethnic profile of the neighborhood looks much different today as continued and diversified flows of immigrants from Latin America and the Caribbean arrive. Residents from places like Honduras, Guatemala, Mexico, Nicaragua, El Salvador and other parts of Latin America began moving into the neighborhood in the 1970s. It is still (comparatively) inexpensive to live here, and it remains

a traditional Latino immigrant gateway neighborhood. Today, Cubans account for approximately 39 percent of the population of Little Havana, and Central Americans, mostly Nicaraguans and Hondurans, account for another 39 percent. Residents from Mexico, the Caribbean and almost all South American countries make up the other 22 percent. In other words, Little Havana is not a "Cuban community" demographically anymore, even if it might be imagined as one.

It is also important to realize the diversity of Cubans living, working or passing leisure time in the neighborhood. Not all of them left Cuba in the 1960s, not all are politically conservative and not all have had access to the same economic, social and political support systems.

The Cubans—Creating Little Havana

1960s

In 1961, there were a few of us in Calle Ocho. At dawn, you'd find a handful of us sitting on a bench where Domino Park is today. Some people played dominoes there even then. Don't know how they got started. It was just a place to sit, next to the [Tower] theater and tell stories and play. But some of us [men] would go there at dawn because there was a new bakery just down the street to the west and the baker would step outside right as the sun came up and yell, "Pan caliente!" [warm bread] and we'd run as fast as we could down there. He'd give it to us free. We had no money. We couldn't pay anyway, so he gave it to us free.
—Berto, twenty-four when he came from Cuba in 1961

It is unclear when the title of "Little Havana" was bestowed on the juncture of the Riverside/Shenandoah neighborhoods, but some residents remember the use of "*La Pequeña Habana*" in the early '60s. In 1963, Milton Bracker, writing for the *New York Times*, described Miami as a town being overrun by Cubans and speaks of 8th Street as "Little Havana": "Boiling less with physical activity than with pent-up feelings that have no true outlet, Miami's Cubans flood the town with Spanish. As in their homeland, they base their diet on *arroz con frijoles*, or rice and beans. Eighth Street, South West, is Little Havana." As late as 1968, a county report on the demographics of Miami referred to the area as "Little Cuba."

The first wave of Cuban exiles amounted to about 200,000 persons, escaping the country's dramatic revolution and subsequent

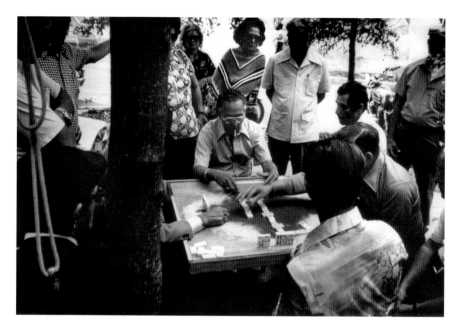

A domino game in Domino Park (when called Antonio Maceo Park), circa 1970s. *Kiwanis Club of Little Havana.*

transformation into a socialist society. The U.S. government facilitated their entry by granting them refugee status, allowing them to enter without the restrictions imposed on most other nationalities. A program was established to assist in the resettlement and economic adjustment of the arrivals. This first wave was overrepresented by wealthy professionals and intellectuals. They are known as the "golden exiles" because of the human capital that they brought with them; many had high levels of education and business experience. We cannot overstate the importance of this wave in shaping Little Havana and the character of the Cuban presence in the United States. Those who came over in this wave possessed skills and attitudes that would facilitate adjustment to life in the United States and give them an enduring political and economic hegemony within the Cuban American community. This was the most economically successful cohort to arrive and the one that received the most economic support from federal and state governments. Furthermore, those early émigrés felt compelled into exile as they found themselves on the losing side of Cuba's internal class conflict. They have, therefore, been the principal standard-bearers in the sustained struggle against the Cuban government, the faithful keepers of the exile legacy.

As early as 1962, the *New York Times* noted that more working-class Cubans, semi-skilled and unskilled laborers, began to migrate to the United States. Of the new arrivals, many relocated outside Miami. Approximately sixteen thousand of the eighty-five thousand who had registered at the refugee center by early 1962 relocated out of Florida. The new settlers of Little Havana came from a group that probably did not have the resources to live elsewhere and were not relocated out of the area.

The second large wave of Cuban arrivals started in the fall of 1965 and was triggered when the Cuban government opened a port and allowed persons from the United States entry into Cuba to pick up relatives who wanted to leave the country. About 5,000 Cubans left from the port of Camarioca before the United States and Cuba halted the boatlift and agreed to an orderly airlift. The airlift, also called the "Freedom Flights" and "Air Bridge," started in December 1965 and lasted until 1973. The twice-daily flights from Cuba to Miami brought 260,500 Cubans to the United States.

The airlift allowed the Cuban government to determine which applicants received a departure permit. Males of military age were excluded, and the government expedited the applications of the elderly. With a predominance of females and the elderly, airlift arrivals had a profile different from the previous wave. In its first few years, the airlift brought the remnants of Cuba's upper classes, especially the elderly parents of those who had left in the earlier wave. But the airlift also peeled away at the middle and lower sectors of Cuba's social class structure: small entrepreneurs, skilled and semiskilled workers, unskilled and white-collar employees. By 1973, the applications for departure had bottomed out, and both governments agreed to terminate the airlift.

One thing we know: the very first arrivals in Little Havana were consumed with the idea of returning to the homeland, but they had to make a living in this temporary settlement. The 1960s was a decade brimming with hope of return. Living in the new land of Little Havana was an adventure, and an important characteristic of the Cuban Exceptionalism explored in academic literature is to make a mark wherever you are. The more entrepreneurial Cubans set up businesses of all types, but their eyes were still on the prize of returning to Cuba.

Little bits of Havana, transplanted to American soil, were blooming in Miami as Cuban refugees re-created some of the things they had back home. Businessmen who once owned large stores in Havana opened small duplicates of those stores in Miami. Miami store owners adapted their merchandise to meet the tastes of their new Cuban customers. One of the first Havana transplants was the Wakamba Restaurant on Flagler Street.

VIGNETTE 1: CAFECITOS AND VENTANITAS

By 1969, seven Miami companies were blending, roasting and packaging the espresso used to prepare Cuban coffee. Most producers had relocated from Cuba, but all had to use beans imported from other Latin American countries, even if they used the same labels as they had in Cuba. Two million pounds of coffee were produced annually.

Cuban coffee was also sold hot and fresh for seven cents in the '60s at open-air cafeterias or *cafetines*, which Anglos described as "stand-up coffee counters." In 1969, an estimated 396 such cafeterias had opened across Miami, most of them in Little Havana.

The ever-open cafeteria windows (*ventanitas*), which faced the sidewalk, were places for dispensing coffee and snacks and for catching up on the latest news and gossip. They had given "enormous impetus to increased street activity," said a 1975 city planning report on Little Havana, as groups of people would stand around the *ventanitas* and chat about news, politics, sports and other topics—a tradition that continues to this day.

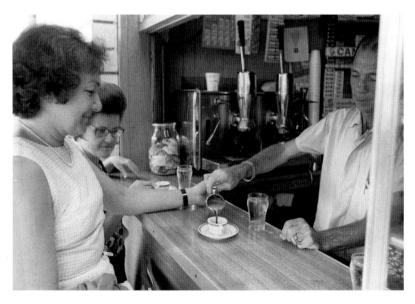

A café cubano break at a *ventanita*, circa 1976. *Richard Gardner, photographer. Miami News Collection, HistoryMiami, 1989-011-4439.*

A legendary cafeteria was Casablanca on Calle Ocho. In 1985, then manager Jose Condé estimated that he dispensed an average of seven hundred *buchitos* (demitasses) every morning to his customers, who began forming a line for their caffeine shots as early as 7:00 a.m. Casablanca was also known for its life-size mural depicting celebrities, superheroes...and a couple locals sipping on their potent drinks at a *ventanita*. At Versailles, open since 1971, more than one thousand *cafecitos* are served from its *ventanita* daily. In the 1980s, a McDonald's on Calle Ocho was the first in the United States to serve a "McCafé"— café cubano to wash down a Big Mac.

Most *ventanitas* did and still do have a jug of cool water for passersby that some use to rinse their mouths of sugar after finishing their hot, sweet drinks. Often customers purchase an accompanying pastry like a *pastelito de guayaba y queso*. *Ventanitas* also maintain the tradition of selling cigars and cigarettes, as well as sodas like Materva or Malta Hatuey, both popular brands in Cuba before 1959.

Café cubano is everywhere. Little Havana's Continental National Bank, the first Cuban American bank in the United States, even has a separate teller window for serving Cuban coffee to its customers. When Academy Award–winning actor Robert Duvall was preparing for his role in the early 1990s' film *Wrestling Ernest Hemingway*, he became a regular customer of an octogenarian Cuban barber in Little Havana who would "bring in a tray with little paper cups full of café cubano and pass them around," Duvall recalls fondly.

Café cubano is also served in Little Havana homes, although the neighborhood's Central American residents typically prefer American drip coffee, not espresso; this coffee is available at Central and South American restaurants, too. Those who like their coffee Cuban style often have a set of demitasse cups for offering coffee to guests at home, as well as a *cafetera*: a stovetop coffee maker. Little Havana residents may drink their coffee in a variety of different ways, depending on their mood, but the *ventanitas* remain an important fixture of culinary and cultural life.

Julio Yuen owned the original restaurant in Havana. The transplanted Wakamba was identical in motif and served the same Spanish-American-Chinese cuisine it had in Havana. In the early 1960s, as many Americans as Cubans patronized the restaurant.

Another sign familiar to former residents of Havana was Ydo's, a yard goods store near the Flagler Street Bridge. Ydo's was run by Basilla Nick and her husband, who had worked for eighteen years to build the business they had in Havana. After the revolution, they arrived in Miami with little money but much enthusiasm. They opened Ydo's by saving pennies. This was a story repeated many times throughout Little Havana.

Many of the existing stores changed as a result of the Cuban influx. One early Cuban entrepreneur took over what had been a typical grocery store for American housewives. He saw an opportunity in the growing Cuban population in the area and took it. "This store is very small, but business is good," said Rodrigues. "We serve Americans, too, but I speak very little English. Will I go back? It will be as it always was—here awhile, in Cuba awhile." The owner of Colonial Market started replacing grits with black beans and rice when the Cubans started coming. By 1962, he had hired all Cuban help from the refugees coming into the area.

Many of the new arrivals were entrepreneurial in their approach to exile. Jose Palmero was one of the entrepreneurial types. When he and Oscar Rodriquez started Ultra Records in Little Havana in 1963, they were just trying to make their $22 investment reproduce enough income to keep them alive. They were attracted to Little Havana because of the cheap rent and

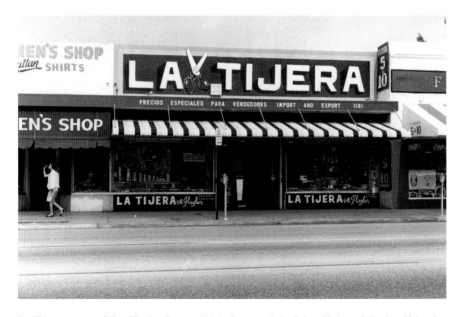

La Tijera store on West Flagler Street, 1966. *Courtesy of the Cuban Heritage Collection, University of Miami Libraries. Arva Moore Parks Photograph Collection.*

a small but growing population of Cubans in the area. The original store in the heart of 8th Street, not far from the Tower Theater, was rented to Ultra Records for $100 a month. Today, the value of that piece of real estate makes it inaccessible to most new immigrants.

Willy Gort, now a Miami city commissioner, remembers when his family opened Gort Photo Studio in the early 1960s. The rent was fifty dollars a month, and they were given three months of free rent as an incentive for starting a business in the area, which was being abandoned by the American-owned businesses following their American clients into the suburbs. The area's economic landscape was in dire shape at that time.

Cuban businesses were also following their constituents, in a way. Some old-timers recalled the presence of Cubans on 8th Street since the 1930s, when political turmoil on the island motivated a small migratory wave to the States. Some of these early arrivals bought apartments in the area, between 8th Street and Flagler. These apartments served as foundation stones and were one of the reasons why post-1959 arrivals settled where they did. Businesses sprang up where the Cubans settled, and the area attracted émigrés not only because of the low rent but also because the public transportation gave easy access to the employment opportunities in the central business district, as well as to the Centro Hispano Católico and the Cuban Refugee Center.

Some early residents lived north of Flagler Street, near La Casa de Fidel (the House of Fidel), where the charismatic revolutionary stayed while recruiting supporters and raising funds for his July 26, 1953 attack against then-president Batista's military installations. Some longtime Cuban residents were supporters of the revolution and left for Cuba after Fidel's rise to power, only to return a few years later to become protagonists in Little Havana's development. Nelida Grenier remembers Flagler Street as being the core of the business district in 1960: "We rented a cheap place on 22nd Avenue and Northwest 2nd Street, but Flagler was where all the stores were. The Ten Cents and the groceries. We'd walk everywhere. *Que remedio.* We had no car." Cubans settled along Flagler and 8th Streets, and the area soon became known as La Saguesera, a deliberate mispronunciation of "southwest" with a Cuban twist.

Grocery stores and restaurants came first. Drugstores, furniture stores, cigar factories, bars and nightclubs followed. Cuban merchants often named their stores after stores they owned in Cuba or Cuban places with special significance. Cubans ate at the Flor de Camaguey cafeteria or at La Habana Vieja (with its murals of Cuba on the walls), and they shopped at the Villa Clara department store. Store signs often dated businesses from when they

Vignette 2: La Saguesera and Flagler Street

La Saguesera (La SAwes-era), Spanglish for "southwest area," is the first moniker that Cubans and other Latinos gave the neighborhood later known as Little Havana. In the 1960s, the center of community activity was not the now famous Calle Ocho but instead West Flagler Street, an east–west corridor that runs straight into downtown and is parallel to (and eight blocks north of) Calle Ocho. Flagler is also one of the oldest streets in Miami, named after one of the city's founders, Henry Flagler.

All along Flagler, the sidewalks bustled with Spanish-speaking pedestrians who patronized local cafeterias, fruit markets, barbershops, restaurants and mom and pop businesses—most of which were Cuban owned by the mid-'70s. The air was animated with the sounds of Spanish: impassioned debates about Cuban politics or baseball, the loud preaching of evangelists standing on street corners, the flirtatious comments of men winking at lady shoppers. Latin music emanated from music stores, portable radios and cassette recorders, and the *shhhhh!* of espresso machines was ever present.

Miami resident and artist Tony Mendoza recalls the "homey" smells of the street during the time he lived there as a youth: the earthy scents of fresh-ground espresso (café cubano) emanating from open *ventanitas* of cafeterias; the smoke from cigars dangling from the mouths of

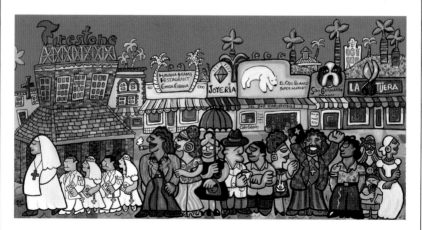

La Saguesera depicting community life on West Flagler Street near 12th Avenue in the 1960s. *Painting by Tony Mendoza.*

old men; ripening tropical fruits like mangos and *platanos* sitting in wooden crates next to *malanga, boniato* and other root vegetables; familiar perfumes and colognes; fresh-baked *pan cubano* (Cuban bread) from the bakeries; fresh meats from the butcher; and the frying of pork or *croquetas.*

A favorite store was La Tijera, a place for catching up on the latest news, not just a spot to buy a pair of scissors, a spool of thread or replacement parts for pressure cookers and *cafeteras.* Some owners let shoppers buy items on credit. Children and adults loved the tropical ice cream at San Bernardo. The Firestone that anchored the corner of Flagler and 12th sold more than tires; one could purchase household appliances like televisions and record players—and even bicycles!

had been started in Cuba, not in the United States. El Credito Cigar Factory, originally started in Havana in 1907, moved to Miami in the early 1960s and proudly claimed its original date of creation (see "Vignette 5: The Cigar Factories and Manufacturers"). Some store names used Spanglish, like Quincalleria Marinao—El Ten Cent Cubano.

Cuban and Latin American products began to fill the shelves of Cuban and non-Cuban grocery stores and supermarkets: Café Estrella, Frijoles Kirby, *mariquitas* (banana chips), Malta Hatuey, guayaba paste and many more. The AM dial became populated with Spanish as radio stations sprung up in Little Havana playing Cuban Top 40 and hotly condemning Castro and the international communist conspiracy that had brought them to this corner of the United States. As early as 1961, the changes to Little Havana were seen as profound and perhaps irreversible. In Little Havana, the Cubans "have created their own comfortable Latin culture," wrote a reader to the *Christian Century* magazine in 1961, "…which they will leave willingly only for the real Havana."

Riverside Bank, deep in Little Havana, did significant business with Cubans; at some banks, Cubans owned at least a quarter of the bank's deposits. Their strength was already being felt. Mr. Pallot, president of Inter National Bank, said, "I consider Cubans as good a risk as Americans. Our experience with them has been excellent. Just like the old immigrants to New York, they are industrious and they get the whole family to pitch in." Inter National helped Cubans go into all kinds of businesses—wholesale, retail,

servicing and manufacturing. The businesses included a shoe manufacturer, bakery, interior decorating business, construction business, used car retailer and several grocery stores. Critics contended that Miami's economy could not support the ever-increasing number of Cubans here. Mr. Pallot, on the other hand, claimed that the Cubans deserved credit for saving Miami's economy. As an example of these successes, in late 1963, with the financial assistance from Inter National Bank of Miami, Vigilio Perez and family founded Delicias Fruits to produce guava jelly and paste. By 1966, sales were totaling $50,000 a month.

Many Cubans reported that major banks were hesitant to make loans to them, no matter how business savvy they had been back on the island. In Miami, Cubans had no collateral. "I didn't even bother to go to the bank because I knew that they could hardly consider giving a loan to an unknown refugee," said Eduardo Sardina, who at the end of 1961, along with his father-in-law, invested $6,000 to start a bakery manufacturing business selling Cuban-style crackers.

In the late 1960s, the small Cuban banks that emerged began to extend "character loans" to those who had solid entrepreneurial roots in Cuba or strong letters of recommendation from respected business leaders. Carlos Arboleya, who had become president of Fidelity National Bank in the mid-1960s, and Luis Botifoll, who became president of the small Republic National Bank in 1970, were among the first to establish these character loans. The practice became recognized as a good business decision to the point where successful Cuban businesspeople often used their positions of power within private enterprises to extend similar opportunities to fellow Cubans. In 1966, Remedio Diaz-Oliver convinced her employer, Richford Industries, a container distributor, to advance $30,000 in credit to a Cuban who had nothing but his reputation going for him. If the man defaulted on the loan, Diaz-Oliver would have had to repay the loan. But he didn't. Instead, he established a successful container distribution business and repaid the loan along with a handsome commission to Ms. Diaz-Oliver. Richford agreed to continue the practice and advanced credit to numerous Cuban exiles. It resulted in a good business decision: mutual growth for lender and entrepreneur.

Some businesses started with very little capital. Cubans who later opened *fruterias* would knock on doors and point to a fruit tree in the backyard; their English-speaking neighbors let them use the surplus, which they then sold to other newly arriving exiles. The fathers of Angel and Guillermina Hernandez met each other this way, having both arrived from Cuba in 1958;

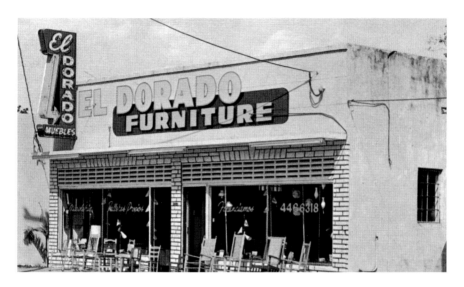

The original El Dorado Furniture store on Calle Ocho, circa 1960s. *Private collection, El Dorado Furniture.*

they opened three *fruterias* in downtown Miami. When Angel (a Bay of Pigs veteran) and Guillermina got married, they started—with the support of their family members—Los Pinareños, still a landmark in Little Havana. To help them get started, they used the same valuable phone book their grandfathers had compiled, listing the names of local homes where they could gather surplus fruit.

El Dorado Furniture, which started with very little capital when it opened in 1967 on Calle Ocho, was one of the first Cuban-owned businesses to get a loan guarantee ($10,000) from the Small Business Administration, which was critical in allowing the business to expand. El Dorado is now one of the nation's top fifty furniture retailers. Founder Manolo Capo was inducted into the Furniture Industry Hall of Fame, and in 2010, Little Havana's 25th Avenue—from Southwest 7th to 8th Streets—was renamed for him.

Demographically, the concentration of Cubans in Little Havana resulted from Cubans moving in and non-Cubans moving out, changing the cultural "feel" of the area. Cuba's patron saint, *La Virgen de la Caridad* (the Virgin of Charity), made her appearance on storefronts and in front yards. Two of the earliest churches to cater to newly arriving Cubans and offer services in Spanish were Riverside United Methodist Church and Calvary Baptist Church. Tamiami Methodist Church became known as Iglesia Metodista Unida Tamiami.

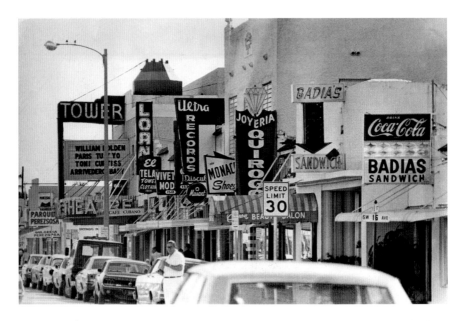

Southwest 8th Street business establishments, including the Tower Theater, 1976. *Richard Gardner, photographer. Miami News Collection, HistoryMiami, 1995-277-3039.*

On September 8, 1960, the Saints Peter and Paul Church hosted the first Mass for *La Virgen de la Caridad*. Even though a well-established Jewish synagogue (Beth David) was also in the Roads, many Cuban Jews who arrived in Miami moved to Miami Beach and joined Temple Beth Shmuel, founded in 1961 to provide a home for Cuban Jews.

San Juan Bosco Catholic Church, built in 1962, was named after a saint who is the patron of youth; it offered programs for the many Cuban youths arriving in Miami and trying to adjust to the upheaval (and trauma) of their move. By 1965, it was already offering six Sunday Masses. Gesu Church, located in downtown Miami, was home to Centro Hispano Catolico, which served as a resource center and handled hundreds of thousands of exile cases from 1959 to 1968. The prestigious Belen Jesuit School relocated from Havana, Cuba, to the elementary school building of the Gesu Church in 1961, but within about a year, it had moved to its own space in Little Havana.

St. Michael the Archangel Catholic Church, which celebrated its first communal Sunday Mass in 1946, opened a new building in 1964 to accommodate a parish that had expanded rapidly after the arrival of Cubans in the area. Two years earlier, St. Michael's had held three additional Sunday Masses, in Spanish, at the Dade County Auditorium, just east of the parish's grounds.

An iconic landmark, the Tower Theater began to transition from screening traditional American movie fare to showing films subtitled in Spanish; it was the first movie house in the county to do so. Eventually, it screened films entirely in Spanish, like the Spanish films of Pili and Mili and Mexican films featuring the famous comedian Cantinflas. For decades, the theater was a popular gathering place for families, kids and couples, offering cheap double features and famous hot dogs. It was also a site for shows and special events. A young Willy Chirino (now a Grammy-winning artist) organized regular dance and music gatherings at the Tower Theater as part of a group called *Añorar a Cuba* (To Long for Cuba). Performers would play and dance to Cuban carnival music inside the theater and out on the street, some of them twirling handmade paper lanterns on long poles (*farolas*).

Perhaps the earliest art gallery in Little Havana was its most unusual. Located across from the venerable Centro Vasco, a Spanish-Cuban restaurant, it was a "mini-gallery" with paintings by Latin artists displayed in a hall-like space only forty-six inches wide by nineteen feet deep. In a statement made by state representative Claude Pepper in 1969 ("The Impact of Cuban Refugees on the Economy of South Florida"), he mentioned the gallery to his peers and recommended that they visit it.

Theater played an important role in dramatizing exile hopes and anxieties. In the early '60s, Cuban theatergoers could see plays in Spanish at Miami Senior High School, Dade County Auditorium, Ada Merritt School and the Asociacion Fraternal Latinoamerica, Inc., a cultural space founded and directed by Cuban émigré Antonio Milla in 1965. Local theater pioneer Teresa Maria Rojas (teacher of Pulitzer Prize winner Nilo Cruz) began her Miami career teaching at Ada Merritt. The most famous Little Havana theater to open, near the end of the decade, was Teatro Marti. Ernesto Capote, formerly the head lighting technician at Havana's Tropicana, transformed a former boxing arena on Southwest 8th Avenue into the theater in 1967. Assisting in the venture was Pepe Currais. Teatro Marti was part of a larger building called Circuito Cineteatral Capote, which included a movie theater. There was no air conditioning, so patrons used hand fans to cool off while watching dramas and comedies that played out their imaginings: characters put in Cuban jail for their dissidence or newly arrived exiles adapting (in comic ways) to Miami.

Established residents expressed concern that the growing density of newcomers would turn the area into a ghetto, but the continued flow of Cubans and the increasing density in Little Havana actually transformed an economically depressed area into a visible commercial and residential

community. By 1966, the *New York Times* had identified Little Havana as the "most interesting and fastest growing" home of the newest arrivals, stretching along Southwest 8th Street from 5th Avenue to 24th Avenue: "Along this street…Cuban retailers supply baked goods, shoes, jewelry, dry goods, groceries, appliances and other merchandise to those of their countrymen who have settled in this part of Miami."

Population density led to an increase in types and intensity of interactions among the residents. Organizations sprang up to institutionalize different types of interactions. Business activity is one form of interaction, but during the early years, Cubans became obsessed with maintaining the culture of the country to which they would soon return or at least their ideal of what that culture was and could be. As Christina Garcia detailed in her book *Havana U.S.A.*, maintaining and reproducing *Cubanidad* (Cuban identity) was the intention of many of the organizations and interactions taking place in Little Havana during this time. Lectures and seminars at local schools and community centers throughout Little Havana dominated the social activities of the neighborhood. Even the names of the seminars expressed the longing of these early exiles: "*Añoranzas de Cuba*" (Longing for Cuba) and "*La Cuba de Ayer*" (The Cuba of Yesterday). These seminars provided hundreds of homesick participants with the opportunity to study their homeland in depth. A course for the elderly Cubans advertised, "We will encourage the exchange of anecdotes and memories with the aim of, perhaps, preserving them before the years take their toll." For the children, schools and churches established after-school programs emphasizing *Cubanidad*. San Juan Bosco Church, for example, opened its Escuela Civico-Religiosa in 1967, offering grade school and high school students religious instructions as well as daily after-school courses in Cuban history, geography and culture. Bilingual public schools, fully certified but modeled on the schools of old Cuba, were established to maintain the cultural traditions of the island. Lincoln-Marti Schools were founded in 1968.

By 1959, Miami High—in Little Havana—had become the largest school in Florida, with 3,300 students, but it would grow still more. One student in Miami High's National Honor Society, which published the student directory, said, "Alphabetizing 300 Gonzalezes can be tedious!" A Miami High junior was chosen in 1965 to represent "Miss Free Cuba" in a Miss Universe Contest.

The changes had some of Miami High's football coaches worried. Bobby Carlton, who served as head coach for Miami High from 1965 to 1967, said that kids who'd just arrived from Cuba "didn't know anything about football"

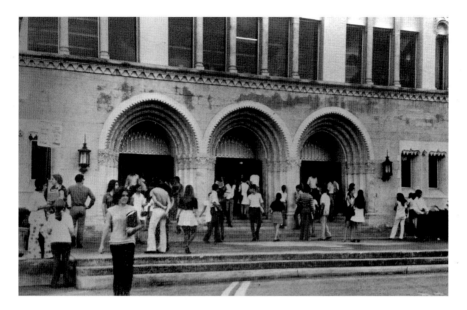

Outside Miami High, circa 1960s. *Courtesy of Miami Senior High School Library Archives.*

and lacked a connection to the school's proud football tradition. Carlton's team had won a state and national championship in 1965, but beginning in 1969, the Stingarees had a losing football season for the first time in forty-three years, and they continued a losing streak for the next half decade.

The changing character of the neighborhood did not go unnoticed. Even at this early stage, the uniqueness of what was happening along Calle Ocho began to attract the attention of city leaders. In the mid-1960s, city planners had discussed a redevelopment plan that included the construction of a mall along Biscayne Boulevard, near the pre-1959 old Cuban neighborhood, and the designation of a portion of it as a "Latin Quarter" where Cuban businesses could sell "Spanish wares from stores decorated in Cuban style." The plan never materialized, but in 1966, the focus shifted to the emerging Cuban business district along the Tamiami Trail. The idea of developing a "Latin Quarter" along Calle Ocho emerged as a way to tap the changing character of the neighborhood.

Although Cubans are not a group usually thought of as having felt the sting of discrimination, early migrants have a more nuanced story about how they were accepted. The reactions by the established residents were mixed. "Some resented us because we spoke Spanish, we would talk too loud and took jobs away from them," remembers Luis Botifoll. "In fact, there were signs that stated: 'No Pets, No Children and No Cubans.'" Local newspapers

reported on the Cuban expansion at times with alarm. A letter writer to the *Miami Herald* complained that Miami was "up to [its] armpits with Cuban refugees." "It's a Cuban invasion!" one local store owner declared in 1963, referring to the large number of Latin-owned shops that now surrounded his business on Southwest 8th Street. In a *Miami Herald* article from February 16, 1964, one business owner complained, "It was an infiltration at first. Then the invasion began…It's knocking hell out of my business. The Cubans trade with their own people and we merchants have to take a loss or sell out cheaply to Cubans. It's unbelievable how the Cubans could push out the Americans in four years time."

Most of these Americans were themselves transplanted migrants, coming from other areas of Florida, Alabama and Georgia, as well as New York, New Jersey, Illinois, Pennsylvania and Michigan, according to the 1960 census. Most of them came to the area for the weather, not for its multicultural character. Indeed, South Florida did not have a history of receiving immigrants. Before the Cubans, it was a typical southern metropolitan area in its makeup and social dynamics. African Americans were segregated from the white population. The mostly white Cuban immigrants were a new type of minority—a cultural minority that was integrated into the white southern social fiber through race and class.

Miami's African American community initially opened its arms, too, or at least withheld judgment about Cuban migrants. An analysis of the African American press in Miami conducted by Guillermo Grenier and Max Castro showed that in the 1960s, the black community was focused primarily on civil rights concerns; the arrival of Cubans had relatively little salience and received scant attention in the black press. As Cubans began to make their presence known, coverage increased, and on occasion, journalists expressed sympathy for the plight of the refugees, but the issues of Cubans were peripheral to blacks in comparison to school integration. Cubans were in Little Havana; blacks were not. Things would change as the numbers of Cubans increased, however. Negative references mounted along with concern about adverse consequences for job opportunities, especially as preferential treatment of Cubans by local officials became more frequent. When Martin Luther King Jr. visited Miami in 1966, he noted Miami's racial hostility and warned against pitting Cuban refugees against blacks in competition for jobs.

Leaders of American labor organizations were also weary of the Cuban migration. "I just left a picket line on a strike that's been directly caused by the situation," one labor organizer said in a *New York Times* interview in 1963.

He referred to the supposed willingness of many Cubans to work for less than local labor.

Yet the Cubans did what they had to do and waited for the demise of the revolutionary government. Little Havana became an attempt to re-create what was lost in Cuba. Older exiles received healthcare from Cuban doctors, ate only Cuban food and had only Cuban neighbors. When they read the newspaper, they could read their favorite columnists from Cuba in Miami newspapers. When they listened to the radio, the stations beamed from Little Havana the glories of the real Havana lost to the revolution. Little Havana became "a golden cage, an artificial paradise, the neighborhood of dreams," in the words of Gustavo Perez Firmat.

The sidewalks of Little Havana were real, however, and the daily lives of Cubans soon developed a familiar pattern. "The Cubans brought with them the institutions, values and lifestyle of Havana, of Cuba, before the revolution," said Gort. "Most people in Little Havana still do their grocery shopping every day like they did in Cuba." Official city reports referred to the area where most Cubans were settling as "Little Cuba" and drew parallels between the Miami Cuban center and the Ybor City neighborhood of Tampa, where Cubans had been settling since the last quarter of the nineteenth century.

POLITICAL CULTURE

The exile ethos of return had a transformative impact on the political culture and the economy of Little Havana. Throughout the 1960s, the University of Miami had the largest CIA station in the world outside of the organization's headquarters in Virginia. With perhaps as many as twelve thousand Cubans in Miami on its payroll at one point in the early 1960s, the CIA was one of the largest employers in Florida. It supported what was described as the third-largest navy in the world and over fifty front businesses, many of them in Little Havana: CIA boat shops, CIA gun shops, CIA travel agencies, CIA detective agencies and CIA real estate agencies. This investment helped exiles hone their entrepreneurial skills and boosted them economically more than it contributed to the destabilization of the Cuban government.

Much of the recruitment for the Bay of Pigs invasion of Cuba took place in Little Havana. In 1960, the CIA began to recruit anti-Castro exiles in Little Havana and the broader Miami area. The recruits underwent training in a

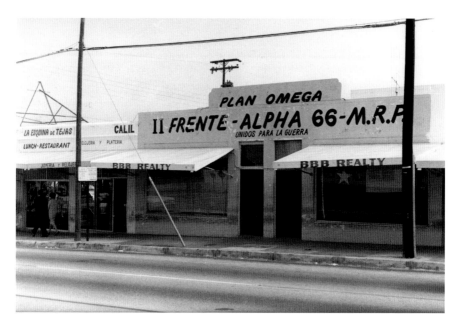

Former Alpha-66 headquarters. UM collection. *Courtesy of the Cuban Heritage Collection, University of Miami Libraries. Arva Moore Parks Photograph Collection.*

variety of locations in South Florida and Central America and eventually named themselves Brigade 2506 (*Brigada Asalto* 2506). Notable brigade members were Manuel Artime (his name is found in a well-known theater in Little Havana), Orlando Bosch (a hero to many although accused of bombing a Cuban civilian airliner and called an "unrepentant terrorist" by former U.S. attorney general Dick Thornburgh), Jorge Mas Canosa (founder of the Cuban American National Foundation, the preeminent lobby organization), Luis Posada Carriles (accused of the same bombing as Bosch although he denied involvement while providing many details in his book *Caminos del Guerrero*) and Alfredo Duran and Antonio Zamorra (political activists and lawyers who were expelled from the brigade for their moderate views).

In his book on the investigation following Kennedy's assassination, Gaeton Fonzi recalls how much of the recruitment and planning for the Bay of Pigs invasion occurred in "luncheonettes" and "dark bars" in Little Havana and was headed by E. Howard Hunt and Bernard Baker:

> *It didn't take long for E. Howard Hunt to inject himself into the labyrinthine world of Cuban exile politics in Miami. With his faithful sidekick, Bernard Barker, Hunt set up a series of "safe" houses for*

clandestine meetings, moved through the shadows of Little Havana and doled out packets of money from dark doorways. (Hunt carried as much as $115,000 in his briefcase.) Although Hunt attempted to keep two separate identities ("Just call me 'Eduardo,'" he told the Cubans) and the source of the funds a mystery, the exiles soon began referring to their benefactors as "Uncle Sam."

The decade of the '60s for Cubans in Miami was counter-revolutionary, not counterculture. The exile hope of returning to Cuba included walking the walk and signing up to overthrow the Cuban government by force. The last official hurrah of that strategy culminated in the Bay of Pigs fiasco on April 15, 1961. After that, the United States officially did not support the exiles' overt belligerent approach and withdrew direct assistance for attempts by the militants to stage attacks on the island. They still occurred, of course, as militant organizations easily recruited willing participants and the CIA was still involved in the activities. During the decade of the '60s, exiles staged 731 reported attacks on island installations. There was no standing down, even though the United States did not officially condone the actions.

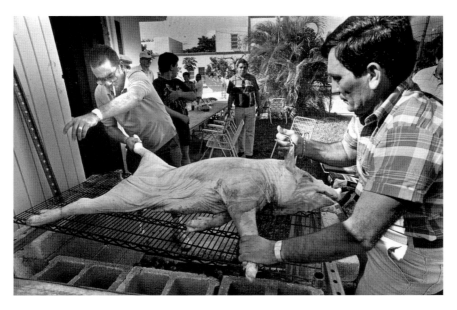

Miami Cubans barbecuing a pig over cement blocks, the *caja china* for preparing *lechon*, circa 1980. *Miami News Collection, HistoryMiami, 1989-011-4485.*

Vignette 3: The Torch of Brigade 2506

In Little Havana's Cuban Memorial Park stands a six-sided obelisk, an "eternal" flame flickering from its highest point. Six bullet-shaped projections surround it, pointing up from the ground. The Torch of Brigade 2506 monument (also known as the Bay of Pigs monument) memorializes the Cuban exiles and four American pilots who lost their lives during the disastrous Bay of Pigs invasion of Cuba on April 17, 1961. More than 100 exiles died in the ill-fated expedition; their names are inscribed on the black marble sides of the monument. Another 1,189 were taken prisoner until the United States paid Cuba $53 million in food and medicine in exchange for their release two years later.

Cuban exiles undertook the invasion determined to overthrow the Cuban government. Backed by the CIA, they had spent months in paramilitary training preparing for the attack. The CIA had recruited

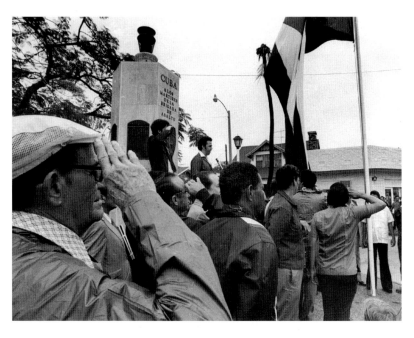

Cuban Student Day protest in front of the Brigade 2506 monument, November 27, 1974. *Joe Rimkus, photographer. Miami News Collection, HistoryMiami, 1995-277-3093.*

thousands of new Little Havana residents for the endeavor. Most of these exiles were men in their early twenties. They had assumed their fellow Cubans on the island would support the attack, but instead, more than one thousand of their former countrymen lost their lives fighting on behalf of the new government.

Installed in 1971, the monument was the first in what was named, in 1973, Cuban Memorial Plaza. Present at its installation were local leaders such as Dr. Bernardo Benes, Sergio Becerra, Alfredo Duran, Angel Perez, Hiram Gomez and Paolo Ramirez. Benes and Duran later became famous for promoting dialogue with Cuba, stirring controversy in the Cuban community (see "Vignette 11: Cuban Memorial Park").

Another important Little Havana space of remembrance is La Plaza de la Cubanidad, a fountain and monument that pays tribute both to the original six Cuban provinces and the drowning victims of the 13 de Mayo, a boat full of families fleeing Cuba that was sunk by the Cuban Coast Guards trying to stop them. The plaza is located at the southwest corner of West Flagler Street and Southwest 17th Avenue.

Since its construction, the Bay of Pigs monument has become a place of gathering and ritual. Every April 17, Brigade 2506 veterans and other supporters crowd around the monument for a remembrance that includes flower wreaths placed at the monument's base and a roll call of fighters killed in battle, followed by a Mass at the nearby Bay of Pigs museum. The monument is also the starting point for the neighborhood's annual Jose Marti Parade, as well as politically themed marches and events.

Latinos of other nationalities have also gathered in front of the monument with signs announcing concerns about political changes within their own homelands. The monument is now a place for protest about current events, not just remembrance of the past.

On December 29, 1962, a crowd of thirty-five thousand gathered at the Orange Bowl to support the Brigade 2506 veterans. The veterans presented the flag of the brigade to President John F. Kennedy, whom many had blamed for the invasion's lack of success. "I can assure you that this flag will be returned to the brigade in a free Havana," said Kennedy. Many in the crowd began shouting, "*Guerra!*" (War!) and "*Libertad!*" (Freedom!).

The culture of Little Havana at this time clearly reflected the exile identity of these early migrants. The exiles did not suffer supporters of the revolutionary Cuban government lightly. *Fidelistas*, as they were called, could not operate with impunity in Little Havana as they could in New York. There were literally hundreds of Cuban counter-revolutionary organizations. The most active ones had their offices in Little Havana. They wanted to get back to their country by whatever means necessary. These were not willing immigrants looking for a new start in a new country. These were forced migrants, excluded from participating in the development of their country by a revolutionary force that had transformed the social structure and made them strangers in their own land. They did not plan to remain long in the Little Havana area or anywhere else in the United States. By the following Christmas, they would cook *el proximo lechonsito*, the next Christmas pig, in Havana or Santiago or wherever they called home.

The transformation of the cultural geography around Tamiami Trail began in the 1960s. By mid-decade, the city of Miami was statistically one-tenth Cuban and was on its way to becoming a major Latin American capital. Latinization of the region began on Flagler Street and then on 8th Street, two backbones of Little Havana. Approximately 60 percent of Cubans living there received financial assistance. The other 40 percent included wealthy businessmen who had resources in the United States or who transferred their fortunes before the Castro regime clamped down. As they settled in the area, they reshaped it demographically and physically. By the end of the 1960s, over 85 percent of the population of Little Havana was Cuban. These Cubans were over 97 percent white and represented about 14 percent of the total Cuban population in the United States. The growth of Cuban-owned businesses reflected the demographic transition taking place in the neighborhood. When, in coming decades, observers comment, with some surprise, on the expansion of Cubans and their businesses to all sections of Miami-Dade County, they are noticing a phenomenon that was localized to the area of Little Havana during the 1960s. Little Havana was the epicenter of the transformation that was about to shake the socio-cultural foundation of all of Miami. What happened in Little Havana certainly did not stay in Little Havana.

Building Little Havana

1970s

The vast majority of the Cubans living in the area are anti-Castro and are supportive of the ousted fascistic Batista regime. Most Cubans, however, are fairly indifferent, who fight and struggle to survive every day. They have no burning desire to "liberate" Cuba. Those who still dream of the BIG DAY are slowly falling into disfavor with the majority of the Cuban community. And, still more important, there is a small number of young Cubans who are considered leftist and who quietly support the Cuban Revolution.
—Republican National Convention After Action Report

The decade of the 1970s was critical to the development of an imagined identity for Little Havana. During this period, many of the iconic events and structures that have now become synonymous with the neighborhood were established or envisioned. Domino Park emerged from the daily practices of Cubans playing dominoes in a shady area of Little Havana, and the now extravagant and famous Calle Ocho Festival came to life in the eyes of the Kiwanis Club of Little Havana. During this time, Cubans in Miami also refocused their attention on local concerns, somewhat adjusting their timelines for a return to Cuba. A substantial portion of the population began to accept the idea of a prolonged stay in this new land—a home away from home, with Little Havana as the center of the new world.

By the 1970s, the population density of Little Havana ensured that Cubans would live nearly complete lives immersed in a Spanish-speaking environment. The intensity of the migration during the 1960s created a dense

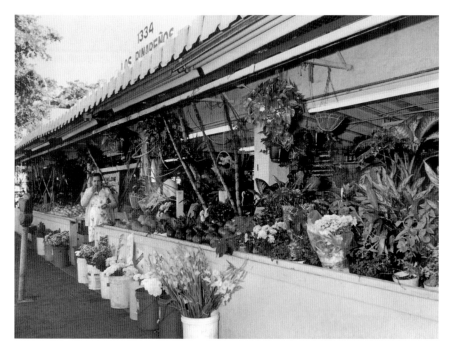

The original building of Los Pinareños *fruteria*, founded in 1967, with Asunción Valdes Hernandez, mother of Angel Hernandez, standing in front, circa 1980s. *Guillermina Hernandez, photographer.*

web of interactions among Cubans that established the foundations of the much-studied Cuban enclave—an economic and social environment where Cubans hired Cubans to serve Cubans. In the social scientific literature, Miami's Cuban community is regarded as the foremost example of a true ethnic enclave in the United States. As presented by Portes and Bach in their 1985 book *Latin Journey*, an ethnic enclave is a "distinct economic formation, characterized by the spatial concentration of immigrants who organize a variety of enterprises to serve their own ethnic market and the general population." The main characteristic of the Cuban enclave is not simply its size or scale but its highly differentiated nature—that is, the high number of businesses offering all the services needed by the community. Little Havana was ground zero for the development of the Cuban American enclave. To this day, Latinos can wake up and carry out their daily activities, from shopping to entertaining to going to a bank or doctor, in a totally Spanish-speaking environment. By the early 1970s, thousands of Cuban-owned businesses lined Calle Ocho, and thousands more small businesses thrived throughout the Miami area. One in every five gas stations in Greater Miami was owned

by Cubans by the 1970s. Some of the cornerstone businesses still operating today were established during this time. La Casa de los Trucos, for example, still does a year-round business selling costumes and magic items. The area was consistently referred to as "Little Havana" by then, and without much investment to attract them, tourists were finding their way to this unique corner of Miami.

The population of the area underwent significant changes as well. The Air Bridge/Freedom Flights continued until 1973, so Cubans never stopped filtering into Little Havana. Although still considered mostly white, these migrants had lower educational levels and were motivated by economic factors rather than political ones. By the 1970s, over 85 percent of Little Havana's population was Cuban. The migration of Cubans to the suburbs increased during the decade, keeping Little Havana as a low-income residential district even as its cultural significance increased. As the *Miami Herald* reported, "Since 1959 the natural first home of the Cuban refugee, the neighborhood, has lost many of its middle income residents to the suburbs. Little Havana remains for them the almost unspoiled source of their cultural identity."

By the mid-1970s, almost 150,000 Cubans had left the Little Havana area and moved to other areas of Miami: Westchester, Village Green, South Miami Heights, West Miami, Carol City and Hialeah. As they moved from Little Havana, Cubans discovered that the established residents of Miami had become accustomed to their presence. They were more easily accepted in previously all-Anglo neighborhoods than the earlier arrivals. According to Ken Rosen of the Greater Miami Board of Realtors, as Cubans settled in other areas of Dade County (Miami-Dade), attitudes of the non-Cuban residents—at least the white ones—adjusted. "The prejudice used to be there. You'd have people tell you, 'I don't want any Cubans next door because they're loud and noisy and they'll be 8 to 10 families in the house before you know it.'"

But even as they moved, Cubans saw Little Havana as their place. It was the spot where Cubans and non-Cubans went when they were in the mood for good Cuban food and that Cuban feel. Local political leaders (none of whom was of Cuban origin at the time) began to see this place as a potential development opportunity. With this in mind, the City of Miami Commission in 1976 established the nonprofit Little Havana Development Authority (LHDA) to promote local economic development. One of its first successes was the completion of Domino Mini-Park, a small plot of land on the corner of 17th Avenue and 8th Street where, on a daily basis, Cuban men,

mostly elderly, convened around wood tables to play dominos. The park consisted of (and still consists of) a dozen tables with chairs and canopies to protect against the rain and sun. The park was also referred to as Antonio Maceo Park after the Afro-Cuban "Bronze Titan" patriot who fought for Cuban independence against Spain in the nineteenth century.

Local businesses benefited greatly from a surge in city interests in the development of Little Havana. Over $8 million in redevelopment funds began to reshape the community with the guidance of the Little Havana Development Authority. Landscaping and other beautification efforts gave Calle Ocho a more Latin feel from 27th Avenue to the heart of the financial district on Brickell Avenue. These early development strategies attempted to view the entire area, from 27th Avenue to the Miami River, as a unit. The beautification efforts along Calle Ocho were matched by a concern for the area of East Little Havana, and the first plans were developed for what would become Jose Marti Park (initially named Latin Riverfront Park).

There was a sense that something unique could emerge from this geographic concentration of Cuban exiles. A *Miami Herald* 1977 editorial expressed the growing sentiment that it was time to recognize that history had bestowed a gift on the community and that it was time to focus on its development:

> *Instead of copying other cities, why not develop something unique to this area? Why not, in short, develop a truly beautiful Little Havana that will become not only a tourist attraction but will provide something of lasting beauty and benefit for those of us who live here year round?… Imagine a tree-lined promenade close to downtown Miami, stretching over many blocks, with shops and restaurants and entertainment spots on either side…It would serve the best interests of the community and of the Cubans themselves if the city would take the lead in providing the cleared space to bring them into a true Latin Quarter with Spanish-named streets, plazas and appropriate architecture. We would be building on what has become one of our natural and unique assets.*

The concept of the Latin Quarter, which was first introduced in the mid-1960s and periodically resurfaced as a development strategy for the neighborhood, never received much support from a significant portion of the Cuban community. At its inception, community leaders who pushed the idea wanted to take advantage of the unique ethnic flavor of the area, but they were hesitant to peg the success of the entire enterprise on one ethnic group. To some Cubans, however, the repackaging of what was essentially the core

of the Cuban success story into a generic Latin Quarter concept amounted to profound disrespect. Those who resisted the idea did not believe that Little Havana was Latino in any general sense. It was specifically a Cuban creation, and any attempt by the city to dilute its Cuban character would be resisted. The demographics of the area at that time were predominantly Cuban, but it was clear that Cubans in favor of the Latin Quarter were in the process of establishing an infrastructure that would benefit immigrants from all of Latin America.

As it turns out, demographically, the advocates for a Latin Quarter were prescient. By the end of the decade, after the success of the Nicaraguan revolution, another Latino ethnic group would establish a numerically important presence in the neighborhood, and the diversity of the neighborhood has continued to increase to the present day.

Still, despite Cuban resistance, the Latin Quarter idea would not die. City leaders were intent on making the area known as a center of Latino cultural activity while also recognizing the unique place that Cubans held in its development. Local writers described Calle Ocho as "the heart of Miami's Latin Quarter" while recognizing its unique Cuban character at the same time. As the *Miami News* reported in 1977:

> *By noon, the noise on the streets seemingly reaches crescendo stage. "Oye tu's!" ("Hey you's") are shouted across sidewalks, horns blare and radios—eternally tuned to Spanish newscasts—blurt out staccato reports. But it is not yet a crescendo. As the sun goes down, and the red, blue and yellow neon lights begin to blink, the intensity increases. At last, it is night in Little Havana. The newscasts are replaced by music—loud music. The traffic in the streets increases, but now, the sidewalks are clogged too.*

As the *New York Times* reported by the middle of the decade, "Little Havana is a self-contained community, providing jobs and total isolation for those who do not want to venture beyond its confines. It is possible to live there and never speak a word of English, never eat an American dish, never deal with an American."

By the mid-1970s, Calle Ocho was referred to in the *Miami News* as "the cultural center for 500,000 Latinos living in Dade and a top tourist attraction for visitors…There is a feeling of safety walking around Little Havana at night—among furniture stores (their wares on the sidewalk), groceries, bookstores and gift shops, all open well into the night." When a group of women from the Miami Junior League asked the Little Havana

Botanica Nena on Northwest 27th Avenue, circa 1970s or 1980s. *Josefina Tarafa, photographer. Courtesy of the Cuban Heritage Collection, University of Miami Libraries.*

Development Authority (LHDA) for a tour of this burgeoning area, the agency's president, Raul Alvarez, and Willy Gort, a member the Kiwanis Club of Little Havana, became the area's first tour guides. When tour requests continued to pour in, they developed Little Havana Tourist Authority and distributed for free a small brochure, *Little Havana USA: Self-Guided Tour*. The guide mentioned a piñata shop, a *botanica*, a cigar shop, the Brigade 2506 monument and a total of twelve other spots of interest, also listing the addresses for sixty area businesses and restaurants and including in its route a span of Calle Ocho from 11th to 19th Avenues.

The restaurants of Little Havana formed the core of the enclave economy. Cuban owners would hire Cuban workers to serve a mostly Cuban clientele. Pedestrian traffic was dense, and there was a variety of destinations: elegant restaurants for late dinners (Vizcaya and Centro Vasco), more casual hangouts (La Lechonera, Casablanca Cafeteria), intimate lounges (Les Amants) and nightclubs (El Baturro)—all staying open until the wee hours, fueling the street life of Little Havana. The enclave also provided the clientele for Spanish and Argentinean restaurants and other Latin American establishments, as well as art galleries and several theaters exhibiting Latino

artists and presenting Spanish-language plays. All-night entertainment was available at bars and nightclubs throughout the neighborhood.

Even a Cuban-owned funeral home made the *Miami News* because of its contribution to the 8th Street nightlife: "Rivero Funeral Home, where like in all other Latin funeral parlors, 24-hour vigils are part of the funeral service. That accounts for some of the night-walkers on 'The Street.' Funerals in Miami have become a special social function among the Cubans; news from Cuba is exchanged and the link with the past is kept alive."

During this period, Versailles Restaurant became a popular watering hole for Cubans and the primary site for anti-Castro demonstrations. Although geographically to the west of Little Havana, Versailles remains the quintessential Cuban restaurant, harnessing the power of the exile imagination. The story of Felipe Valls, the founder of Versailles, is itself the quintessential Cuban success story. An entrepreneur from Santiago de Cuba, Cuba's second-largest city, Valls came to the United States "temporarily," like many Cubans, in 1960. He worked selling restaurant equipment during most of the 1960s until he decided to open a small over-the-counter sandwich shop in 1971. His empire expanded, and in a couple of decades, he owned a number of restaurants and franchises and employed over 2,400 workers.

In 1978, international attention was brought to Little Havana when the Kiwanis Club launched "Open House Eight, an Invitation to SW 8th Street." The huge and unexpected success of the event led to other grand initiatives, or at least plans, and it also put Little Havana and Calle Ocho into the imaginations of a global audience. A Latin Specialty Center, consisting of a lushly landscaped nine-acre plaza by the river (where Jose Marti Park now stands) with Latino-oriented restaurants and specialty shops, was envisioned to serve as a gateway to Little Havana from downtown. The hope was to turn the river into a tourist attraction, like Ghirardelli Square in San Francisco, which would lead visitors to Calle Ocho from the east. The plan never materialized, but its formulation showed that Little Havana, as a cohesive neighborhood, was receiving attention.

During this decade, the city's planning department hired Jose Casanova, a Cuban-born architect who served—until his retirement—as an ardent champion for development projects within Little Havana, working to find the funds and contribute to the designs of memorials, parks and other public spaces. "This was my first neighborhood in the U.S.," he said about his affection for the area. "I lived here for eight to nine years. It's the place where I got married, where I found my first friends in the U.S., where I shop, where I go to church [San Juan Bosco], where I dine, where I go to the

Vignette 4: Calle Ocho Festival

In 1978, the nonprofit Kiwanis Club of Little Havana launched "Open House Eight, an Invitation to SW 8th Street." Organizers expected no more than 10,000 people to attend the festival, but the turnout was close to 100,000. News outlets worldwide described the event and, in doing so, helped promote tourism to Little Havana.

The festival is now considered one of the biggest Latino street parties worldwide, attracting millions. It extends approximately eighteen blocks along Calle Ocho going as far west as Southwest 27th Avenue. According to Leslie Pantin Jr., former Kiwanis president, the event was created so "new neighbors would get to know newcomers," as the neighborhood was experiencing an influx of immigrants. Tensions were also running high among local ethnic groups. "We didn't call it Calle Ocho," Pantin said, "because we wanted to be Anglo-sounding. We called it Open House Eight. It was the Anglos who started to call it Calle Ocho."

At that first event, Gloria Estefan and the Miami Sound Machine (who had just released their first album a year earlier) performed. Unscheduled street performers showed up, including a man who attracted a crowd of hundreds when he placed a mirror in front of a fighting rooster, letting it spar with its own image.

The next year, Celia Cruz ("The Queen of Salsa") and Tito Puente ("El Rey de Los Timbales") performed, as did Julio Iglesias. By 1984, the festival was attracting more than 700,000 attendees, with local groups and international stars representing an array of Latin and Caribbean musical genres. Eventually, the festival became part of a multi-day Carnaval Miami celebration, although fewer events take place in Little Havana than in previous years. (In 2010, for instance, an eight-kilometer foot race was moved from Calle Ocho to Key Biscayne.)

Carnaval Miami has not been free of controversy. In 1981, a small group of Cubans who had arrived through Mariel showed up unannounced at the Carnaval's Orange Bowl event, excited to perform a *comparsa*. They were not allowed entrance. "The *blanquitos* [wealthy whites] had set up their own *comparsa*," said Natividad Torres, a black Cuban writer and intellectual who arrived in Miami via the Mariel boatlift in 1980, "and many people in this other group were poor and

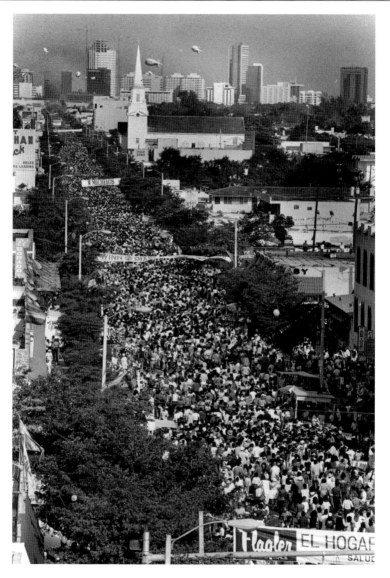

A bird's-eye view of the public gathered for the Calle Ocho Festival, 1998.
Courtesy of the Cuban Heritage Collection, University of Miami Libraries.

black. So the *jala jala* [the hullabaloo] began." The crowds chanted, "Let them in! Let them in!" and held up the show until the musicians and dancers were allowed to perform.

In 1982, the festival began holding an annual beauty pageant. That same year, judges also picked a festival king or queen. The first king was Desi Arnaz, who arrived at the Orange Bowl celebration pounding a conga drum and singing "Cumba, Cumba, Cumbanchero." In 1983, Olga Guillot was picked; in 1984, it was Celia Cruz. On Calle Ocho's ten-year anniversary in 1988, festival-goers broke the *Guinness Book of World Records* with the largest conga line in the world, led by Gloria Estefan as her "Conga" hit blared from loudspeakers. To this day, it is a tradition for conga groups to sing, play, dance and drum as they push through the crowds. Every year, festival organizers choose another world record to break.

"*Aqui está toda la America Latina, no solo los cubanos*" (Here is all of Latin America, not just the Cubans), said a Dominican festivalgoer in 2003. Many people wore flags as part of their outfits or draped flags from their shoulders to their feet (a tradition that continues to this day). One vendor was local hairdresser Samy, who eventually became a star on the Home Shopping Network and earned a star on Calle Ocho's Walk of Fame. Standing underneath a "Samy Hair Design" balloon, he would hand out hot pink visors that said "100% Samy."

Famous names in Latin and Caribbean music have performed at the festival, including Oscar d'Leon, Pitbull, Johnny Ventura, Grupo Niche, Daddy Yankee and local *charanga* favorite Hansel y Raul. One year, however, three shows were cancelled when groups were discovered to have performed in Cuba. After a successful lawsuit by one of those artists, the Kiwanis were not so quick to cancel shows.

Vendors still sell Latin American food favorites (roasted corn, *tamales*, *churrasco* and *arepas*) and cheap trinkets made in China (but with flags of Latin American/Caribbean homelands). Corporate sponsors offer free product samples. Radio stations sponsor the main stages at the festival, but there are plenty of informal performances of Peruvian music, Uruguayan rock music and rumba in front of Calle Ocho stores. Within the last decade, the festival has featured a separate stage celebrating the Carnaval de Barranquilla (Colombia's most famous carnival).

The Calle Ocho Festival was named the official state festival of Florida in 2010.

movies…I used to go to the Tower Theater when it showed Spanish movies. It has had a tremendous impact on the rest of my life."

The 1970s saw the rise of institutions created to address Cuban needs. The Cuban American National Council (CANC) was established by Guarione Diaz to address the resettlement needs of Cubans in the new country. The council realized that Cubans would be unlikely to return to live in Cuba and that their plight in this country was framed by the social forces shaping the lives of other minority communities. From its offices in Little Havana, the council helped new arrivals with housing needs and employment opportunities.

In 1971, the city formed a new community agency for Latinos, based in Little Havana, as a pilot project. The purposes of Acción were to help local residents access community services to which they were entitled; to improve relations among refugees, blacks and whites; to provide better educational opportunities for children and adults; and to form civic organizations. Little Havana business leader Bernardo Benes was head of the Cuban Services Committee of the Greater Miami Coalition, which approved the project.

The Little Havana Activities and Nutrition Centers of Dade County, Inc. (LHANC) was founded in 1973 by Rafael Villaverde, a veteran of the Bay of Pigs invasion. He established the first Hispanic branch of the American Red Cross in 1972, and in 1973, he established the LHANC. He realized that the members of the Cuban population in Little Havana were older than the average immigrant population. Indeed, Cubans in the United States at the time had a median age of thirty-six, higher than the non-Latino population as well as other Latinos.

The LHANC became significant in Little Havana for political reasons as well. During the 1970s, Cubans began to become naturalized U.S. citizens at a record rate. Most of the elderly utilizing the services of the LHANC were registered voters by the late 1970s and early 1980s. Candidates of all political stripes realized that the centers facilitated access to motivated voters, and soon the centers became key stops in all campaigns. The centers provided free transportation to and from the voting booths on election day as well, so their significance in the eyes of candidates increased with each election.

In May 1974, Continental National Bank, the first Cuban-owned and Cuban-operated bank in the country, opened its doors in Little Havana. Of the 250 shareholders, 200 were Cuban exiles. The bank quickly became a major player in the business development of the neighborhood.

Vignette 5: Cigar Factories and Manufacturers

Little Havana remains a mecca for enthusiasts of *puros* (cigars), which aficionados smoke on sidewalks during a game of dominos, in a park or a plaza or on patios. Cigar factories opened in Little Havana soon after the 1959 influx of Cubans. Some factories, like Tobano Cigars, were small operations, with six rollers producing about seven to eight hundred cigars daily. Others had a much larger workforce.

Two that opened in the early 1960s are still in business: Sosa Family Cigars and Padrón Cigars. In 1964, Jose Orlando Padrón started selling cigars from a modest storefront on West Flagler Street, continuing the family business from Cuba. A friend who worked at the Cuban refugee office remembered that Padrón had carpentry skills and gave him a hammer when he arrived; early carpentry jobs made his career possible. Padrón used to make cigars himself when he first started; he sold them at local cafés and cafeterias. By 1966, his factory was selling 300,000 cigars a year. Despite his success, however, Padrón was targeted by the anti-Castro group Omego 7 after participating in negotiations with the Cuban government over the release of Cuban political prisoners. He

A cigar roller at work in an early Little Havana cigar factory, circa 1970s. *Kiwanis Club of Little Havana.*

put a quote by Cuban independence leader Jose Marti on the front of his store: "There are two groups of men: those who love and build and those who hate and destroy." Padrón cigars are now considered some of the best in the world.

One of Little Havana's most famous cigar factories was El Credito Cigar Factory on Calle Ocho. Established in Cuba more than one hundred years ago, the Little Havana factory was opened in 1968 by Ernesto Perez-Carrillo Sr. By the 1990s, it employed more than fifty cigar rollers and was the largest factory in Little Havana. El Credito manufactured the widely recognized brand La Gloria Cubana, which originated in Little Havana (not Cuba). A few years ago, the family sold the business to a multinational corporation based in Denmark, and in 2014, the Little Havana location was closed.

In the late '70s, Little Havana had about twenty cigar factories, some of them tiny, but cigar rollers were hard to find. In Cuba, the art of cigar rolling was passed down from father to son, but in Miami, young people weren't interested in learning the trade. An unexpected and temporary benefit of the Mariel boatlift in 1980 was the arrival of a skilled cigar-rolling labor pool just when some of the smaller cigar factories were moving to Central America because of the labor shortage.

The patriarch of Puros Indios Cigars (now Reyes Family Cigars), Rolando Reyes Sr., started his own tobacco factory at age twenty-one and opened his first U.S. store in Union City, New Jersey, before moving his main factory to Honduras. He opened the Miami location in 1984, but it is now run by his grandson, Carlos, who still hires local cigar rollers.

A year after Puros Indios opened, El Credito was down to fifteen cigar rollers. By 1987, Padrón no longer used any local cigar rollers. Many manufacturers were shipping cigar-rolling jobs to the Dominican Republic and Central America, where labor was cheaper.

In 1994, the Bello family opened a factory in Little Havana; its original factory in Havana, Cuba, dated back to 1896. Now most of Cuba Tobacco Cigar Company's cigars are made in Honduras and Nicaragua, but a few rollers remain in Little Havana, making cigars in front of interested tourists who pass by its headquarters on Calle Ocho.

In the '90s, another well-known *fabrica* opened: La Tradicion Cubana, run by Luis M. Sanchez. In 2006, an arson fire destroyed the

factory where fifty rollers had once worked and consumed Sanchez's and other popular businesses like the Spanish-language bookstore Libreria Cervantes. Sanchez opened a retail store in a much smaller location on Calle Ocho, but his cigar rollers are now based in the Dominican Republic, where he has a factory.

After 2000, the statewide ban on smoking in public places, as well as tax increases on cigars, hit Little Havana's cigar industry hard and led to a continued loss of local cigar-rolling jobs. Nonetheless, the boutique factory El Titan de Bronze Cigar Mfg., which Carlos and Marta Cobas opened in 1995, still makes most of its cigars in Little Havana. The factory hires only "Level 9" cigar rollers (the highest ranking for cigar rollers in Cuba). In 2014, the factory expanded its space and hired additional rollers.

Some of the remaining cigar places are popular as much for providing a place to smoke, talk and build business relationships and friendships as they are for selling cigars and cigar merchandise. Some are popular for enjoying a drink of wine, rum or café cubano (e.g., Art District Cigars, CubaOcho and Little Havana Cigar Factory) or dominos (e.g., G.R. Tabacaleras Co., Cuban Crafters). Top Cigars, owned by Cristobal Mena, hosts regular, informal gatherings of traditional rumba.

In the decade of the '70s, Cubans in Miami were changing their looks and attitudes toward their situation in the United States. The narrative began to develop that the Cuban migrants were the "most successful immigrants in American history," as a teacher at Little Havana's Ada Merritt Junior High reported to the *New York Times* in 1971. The significance of the claim, as arrogant as it might sound, was that Cubans were now, ten years into their settlement of Miami, seeing themselves as immigrants rather than exiles. They spawned institutions that solidified their hold on this part of the continent. The Cuban kids attending Ada Merritt and Miami High in Little Havana wore bellbottoms and long hair. Parents attempted to maintain traditions and were concerned about the crime and drugs that seemed endemic in the United States, but the times, they were a-changing for Cubans as well.

From 1977 to 1979, a group of writers, producers and actors, most of them based in Miami, crafted a series of programs of a low-budget

bilingual television sitcom they called *Qué Pasa USA?* Sponsored and initially transmitted by the public television station in Miami, the series was based on the comical (and sometimes plaintive) misadventures of a family of Cuban immigrants adjusting to life in 1970s Little Havana. The series met with unexpected success because its creators crafted the fictional Peña family in a manner so faithful to the social reality around them that Cuban Americans could see themselves mirrored in the situations, triumphs and trials of the Peñas. To this day, it is continually being rebroadcast by public and cable television stations in Miami and in many cities throughout the country.

In the series, Pepe and Juana arrived in the United States in the 1960s with their two young children, José Jr. "Joe" and Carmencita, who by the time we catch up with them in the 1970s are teenagers in high school. Bilingual and bicultural, Joe and Carmencita constantly face the conflicting normative expectations of the outside "American" world and their parents' traditional Cuban world and provide much of the cultural counterpoint on which the series thrives. They are the principal sources of the challenges to Pepe's traditionalism.

The influence of the home country is reinforced by Juana's parents, Adela and Antonio, who also live in the family's modest Little Havana home. The elderly couple, who no doubt arrived through the airlift a few years after Pepe and Juana, represents bulwarks of Cuban traditions, but unlike their daughter and son-in-law, their ages make them immune to any expectation that they need to adjust to the ways of a new country (including learning English). They are usually baffled and bewildered when they confront the unfamiliar, to which they are ultimately impervious. They are nostalgic for the lost homeland, a place far superior, of course, to the new world they now face. *Qué Pasa USA?* so brilliantly portrayed and encapsulated the experience of Cuban American families during the first couple of decades after their arrival in the United States that it can serve as a prototype for presenting the principal features of the family organization of Cubans in this country, features that largely persist to this day.

Incorporation into the political structure of the United States was a slow, laborious process. Between 1961 and 1973, only 43,472 Cubans in Florida became American citizens. In 1976, there was a surge of activity, and approximately 40,000 Cubans applied for naturalization. This number was more than four times that of any year since the migration began in the early 1960s. Government assistance was drying up as well. Only 5,000 mostly elderly and unemployable Cubans were receiving financial assistance under

the Cuban refugee program by the mid-1970s. At one time, the refugee program sent checks to more than 65,000 Cubans.

The political profile of the population was changing as well. In the 1968 and 1972 presidential elections, most Cubans eligible to vote cast their ballots for Richard Nixon. But analysts expected most Cubans to vote for Jimmy Carter in the 1976 elections, given the fact that 60 percent of new Cuban-born voters were registering in the Democratic Party while 35 percent were registering Republican. Eight years previously, they had registered 60 percent Republican. The shift to the Democrats was attributed to the Watergate scandal when Nixon threw the Cuban "plumbers" under the bus. By 1974, the number of registered Cuban voters was still relatively low—thirty-six thousand—but they were already making a difference. The first Cuban elected official in Dade County was Manolo Reboso, who won a seat in the Miami City Commission in 1972. Although the election was nonpartisan, Reboso was a liberal Democrat and veteran of the Bay of Pigs invasion.

This shift from exile to immigrant was evident in the willingness of many to talk about resuming trade and travel to the island. A 1975 *Miami Herald* poll revealed that 49.5 percent of Cubans were at least willing to visit the island. This was a surprising revelation to hardliners in the community. Letters to the editors supported reestablishing diplomatic and trade relations, and many even questioned the wisdom of the embargo. Even businesspeople, usually the most conservative lot, were weighing the pros and cons of trading with the enemy. For example, the local cigar industry had always felt that competition from Cuba would damage business, but Jose Padrón, the owner of Padrón Cigars, stated in 1975 to the *New York Times* that imports of Cuban cigars might benefit the local industry: "It will stimulate interest in good, hand-rolled cigars and will demonstrate that our products are just as good as the best they produce over there."

But the conciliatory feelings were not unanimous. In 1976, Senator Edward Kennedy introduced a bill to end the U.S. ban on trade with Cuba. This prompted the members of the Bay of Pigs Brigade 2506 to demand the return of the flag that they had presented to the late President Kennedy during his Orange Bowl visit in 1962.

As the Cuban community began to take on attitudes of immigrants rather than exiles, other immigrants increased their numbers in Little Havana. During the '70s, more than 170,000 Latino immigrants arrived in Miami from countries other than Cuba, principally Nicaragua, Honduras and Colombia. These immigrants followed in the footsteps of the early Cubans, and many settled in Little Havana even as Cubans began their colonization

of other parts of Dade County. By the end of the decade, other immigrant groups had begun to establish themselves in the neighborhood. Nicaraguans, fleeing the success of the 1979 Nicaraguan revolution, settled in East Little Havana, and a few blocks in the area became known as Little Managua.

POLITICAL CULTURE

The obsession with Cuba and its politics and traditions did not decrease even as the community established roots in Little Havana. In 1971, when Cuban exiles in Miami learned that Castro had banned all celebrations of the Epiphany on the island because it interfered with the sugar cane harvest, they responded by organizing the Parada de los Reyes Magos (Three Kings Parade) down Flagler Street in Little Havana.

Compared to the 1960s, when the more than two hundred anti-Castro groups had regular meetings and rallies, the beginning of the 1970s was a less active time. The U.S. government had officially ceased its support of armed intrusions into Cuba, and the hard-line militants were sensing the passing of history. The *New York Times* reported in 1971 that "interest in political activities had been minimal of late. Only a handful of exile organizations are barely active…On the whole, concern amongst exiles over what is going on in Cuba is on the wane."

Recognizing that the return to Cuba would be a long-term process, the Cubans in Miami began to reshape their lives and the lives of their neighbors. Cuban businesses numbered around six thousand and had expanded beyond the Little Havana area. The culture was deepening in many ways. New Spanish-language theaters had opened in Little Havana, like Teatro de las Mascaras, founded in 1969, and Teatro America in 1977. In 1978, Teatro America premiered the stage play *El Super*, written by Ivan Acosta; the play inspired an award-winning film version directed by Leon Ichaso and Orlando Jimenez Leal. It was the first film to capture the struggles of Cuban exiles for an international audience. The film's marketing poster had the following caption: "From the people who brought you the rumba, the mambo, Ricky Ricardo, daiquiris, good cigars, Fidel Castro, cha-cha-cha, Cuban-Chinese restaurants and the Watergate plumbers."

TV channel 23 became an all-Spanish language channel in March 1971, and other stations were including Spanish in their newscasts. Of Miami's fourteen AM stations, three were full-time Spanish channels. Besides the one

daily newspaper in Spanish, *Diario las Americas*, there were dozens of weekly and biweekly publications circulating in Little Havana directed at the growing Cuban audience. Most had political messages as their motivation for existing, but they were also used to advertise the Cuban businesses in the area.

The exile ideology began to reshape the political geography of the area with the dedication, on April 16, 1971, of a "modest monument" on the tenth anniversary of the ill-fated Bay of Pigs invasion. A year later, in 1972, a more elaborate and still-existing monument on 8th Street and 13th Avenue was designed by Manolo Rebozo and sculpted by Tony Lopez, who designed other sculptures in what would become Cuban Memorial Park.

On August 21, 1975, the United States announced a partial lifting of its trade embargo against Cuba. Two days later, two hundred Cubans marched through Little Havana protesting not the policy change but the high utility and insurance rates in Florida. This was understood to be a sign of the exile-to-immigrant changes taking place in the community. The rapprochement policy of the Nixon and Carter administrations was welcomed by some elements of the community. The change did not sit well with the militant core of the exile community. The militancy of exiles sometimes clashed with the stability desired by immigrants.

The 1970s was a period when passions ran high among the militants who still sought to dislodge the Cuban government from its moorings through violent means. While the U.S. government had officially stopped supporting armed incursions into the island, the militants were not dissuaded from violence that easily. Violence increased against members of the diaspora who were considered to be traitors to the cause. The FBI considered the Cuban American paramilitary group Omega 7 to be the top domestic terrorist organization operating in the United States. But one man's terrorist is another man's freedom fighter, and violence increased against those suspected of legitimizing the Cuban government by word or deed. Bombings in Little Havana were not infrequent occurrences. Periodically, the Miami offices of international companies that traded with Cuba were bombed.

On April 20, 1976, a car bomb awaited Emilio Milian as he left his radio show on WQBA, *La Cubanisima*, in Little Havana. Milian had been a compelling voice advocating tolerance and speaking out against violence in the name of anti-Castroism on his show *El Pueblo Habla* ("The People Speak"). Hours after the bombing, his legs were amputated at Jackson Memorial Hospital.

Although the attacks took place throughout the decade, there was a surge in hostilities in 1974 and 1975, when three Cuban exiles were assassinated

within an eighteen-month period and about one hundred bombings took place in Miami, many of them in Little Havana. No one was apprehended. The terrorist group Youths of the Star claimed credit for three bomb blasts and said they were retaliation for the arrest of Humberto Lopez Jr., a militant jailed for possession of explosives and weapons. Although the Pedro Luis Boitel Commandoes, another militant underground organization, claimed responsibility for some of the bombings, the president of the 2506 Brigade Association (Bay of Pigs veterans) blamed the bombings instead on "infiltrated Communist agents." Local officials called for federal help to squelch the outburst of terrorist bombings and violence, and the mayor, Maurice Ferre, set up a task force to crack down on the wave of bomb blasts, which also affected hotels in both Miami Beach and Miami.

The violence against Milian and others was seen as a warning to Cubans who were willing to suggest that a rapprochement should take place between the Cuban exile community and the Cuban government. The entire decade was marked by explosions and hostility toward individuals and groups advocating a conciliatory approach to relations with the island. An estimated 279 violent actions by Cuban paramilitary groups occurred in the United States during the 1970s. It can be argued that this violence served to discourage the desire by Cubans in Miami to normalize relations with Cuba. Undeniably, the violence had an impact on Little Havana, directly and indirectly. Directly, the bombings and threats contributed to the establishment of an urban setting of suspicion, uncertainty and silencing. One longtime Little Havana resident recalls her father talking about this period: "You can't talk, you know. You can't really talk [about] your ideas." Indirectly, the bombings shaped the political culture of the area as Cuban American leaders realized that the only sustainable existence of Cuban émigrés would have to be a full incorporation into the political system and a complete termination of terrorist activities. This was the road taken in the 1980s, as Cubans in Little Havana and the rest of Miami registered en masse and shaped the political, economic, cultural and social development of South Florida.

New Cubans and Political Power Come to Little Havana

1980s

On April 1, 1980, a significant event at the Peruvian embassy in Havana initiated a series of decisions by the Cuban government that led to a mass exodus from the port of Mariel, west of Havana. The port was opened for unrestricted emigration and gave the name to a boatlift that brought, in a manner uncontrolled by the United States, more than 125,000 Cubans into the country. It was not as large as the previous waves, but it took place during only five months (April 22 to September 27). Throughout the rest of the 1980s and the early 1990s, there was a lull in migration from Cuba. Only about 2,000 Cubans were being admitted by the United States each year. Based on 1980 census data, the Cuban population of Little Havana reached its peak in the 1980s with 95,522 people of Cuban origin.

The Mariel exodus was a chaotic migration via a flotilla that went to the Port of Mariel in Cuba from Key West, Florida, to pick up relatives of persons already residing in the United States. More than just the relatives boarded the boats, however, and the result was a wave that is perhaps the closest to being representative of the Cuban population. It included, for the first time, sizable representation from Cuba's lower socioeconomic sectors and its nonwhite population. There were writers, artists, a significant representation of the Cuban LGBT community and even government officials. About 20 percent were teachers, and a good number were professionals—nurses, computer operators, etc. Most were workers, skilled and unskilled, and their presence helped fuel the growth of the enclave businesses.

Much of the blame for a deterioration of the neighborhood was placed on this sudden influx of tens of thousands of Cubans, however. They were stigmatized by the presence of approximately 1,800 convicted felons arriving in the boatlift. Many within the established Cuban community of Little Havana did not consider the Mariel arrivals to be cut from the same exile cloth as the previous waves. The term *Marielito*, which became a common term to describe those arriving on the boatlift, revealed the evidence of this differentiation. While *ito* could mean a term of endearment, the suffix also implied "little" or "lesser." Although many arrivals went on to help reshape the Little Havana economic and cultural landscape, their initial impact on the community was viewed as negative.

The Orange Bowl became a processing center and temporary shelter for hundreds of homeless Mariel refugees. One official called it the "Cuban Holiday Inn," but a volunteer explained that refugees were only provided a shower, towel and piece of soap: "We don't want them to like this place too much." The refugees spent nights on canvas cots under the stadium's grandstand. In July and August, the refugees had to move out in preparation for upcoming games, and they were settled in what would be called "Tent City" under I-95 on the eastern border of Little Havana.

While the area still maintained its Cuban feel, new arrivals from other Latin American countries were also settling within the confines of a strong linguistic enclave. The Cuban-dominated landscape began to give way to one of mixed Latin American nationalities. Along major thoroughfares, like Calle Ocho and Flagler Street, storefronts displayed colors and symbols of many Latin American, especially Central American, countries. In Nicaragua, the Sandinista revolution provoked successive waves of Nicaraguan immigrants to South Florida beginning in the late 1970s and continuing throughout the 1980s. By the end of the 1980s, sixty-eight thousand Nicaraguans had settled in Miami-Dade County. Many chose to live in East Little Havana.

The population of Little Havana was also aging, and many of these aging Latinos, mostly Cubans, were also poor. By the 1980s, the largest concentration of older Latinos in the county lived in Little Havana. According to a 1986 study of residents in Little Havana by Florida International University, about two-thirds of the population over sixty earned less than $7,000 per year.

In the 1980s, the neighborhood had fallen into disrepair, with low rents and high crime rates. The effusive excitement of the 1970s, when Little Havana was the core of the Cuban success story, was being replaced by urban decay as the middle class migrated to the suburbs. The conditions and safety in one section of East Little Havana reached a point that some

VIGNETTE 6: TENT CITY

"Tent City" was the name given to a temporary camp that was set up under I-95 after the Mariel boatlift in 1980, after the Orange Bowl was no longer available as the game season was about to start. Dade County was suffering from a severe housing shortage, with a less than .05 percent vacancy rate for apartments. Miami mayor Maurice Ferre said hopefully, "The federal government has been responsive in the past. I assume it will be again."

The federal government agreed to finance construction for a new Tent City for the refugees in an old baseball field under the I-95 overpass and along the Miami River in Little Havana; it also approved spending to cover food for the new arrivals.

Residents and business owners near the site were not pleased by the news. Neighbors worried that the refugees would worsen an area that was already troubled by alcoholism, drugs and juvenile delinquency. The manager of a local day-care center was upset that the 210 children

Kids play in a new area of Tent City, September 25, 1980. *Bob Mack, photographer. Miami News Collection, HistoryMiami, 1995-277-3112.*

in her program had lost their recreation area. Twelve area firms tried to block erection of the tents by filing a lawsuit, but it was dismissed in court. By July 22, bulldozers were already clearing the field.

Tent City operated under the authority of the federal Cuban-Haitian Task Force. Health officials visited the camp in early September 1980 and cited sixteen health and safety violations, at which point they gave the city an ultimatum: clean up the camp within twenty-four hours or move the 750 resident refugees. City employees fixed the problems, but still it was not the paradise many hoped for. "For this, you might as well send me back to Cuba," remarked one refugee.

referred to it as "Little Vietnam," referencing the danger and destruction in Vietnam during and after the war. As Commissioner Willy Gort remembers, "No Vietnamese ever lived there as far as I know. But the area looked like we imagined Vietnam looked after the war."

The problems that faced Little Havana after Mariel preceded the new arrivals. During the 1970s, it became the area with the lowest rent in an already low-rent district. "This is a problem that started before Mariel," said Leonel Alonso, president of the Merchants and Property Owners Association. "This has always been an area for vagrants and bums and drunks." But with the influx of an estimated twelve thousand refugees and an explosive 66 percent population growth, the area came dangerously close to becoming "the first Hispanic slum in Dade County," as a 1982 City of Miami report warned. Longtime residents of the area complained about *cuarterías*, single-family homes that had been converted into rooming houses. In some instances, more than fifteen people, many of them refugees, lived in a house with one bathroom and one kitchen. "It was miserable," says Jose Casanova, who at the time was a planner for the City of Miami. "You saw a lot of old houses burning down…because of overcrowding…You had [houses] designed for one family, and you had fifteen people, with wires, extension cords all over the place, they burn the house…it was too much for a house to hold."

City leaders felt the need to intervene by establishing a task force that would attempt to "revive" the twenty-one-block area of East Little Havana and control the "damage" to the rest of Little Havana. These leaders feared that Little Havana would become "a transient place" for "less desirable

people…if steps aren't taken to keep current residents and businesses from fleeing to the suburbs," said Willy Gort to the *Miami Herald* in 1982.

The arrival of the boatlift contributed to the ethnic polarization within Miami's minority communities. For blacks, Mariel meant more job competition and heightened frustration about their apparent slide to third place from second in prosperity and political power. The marginalization of African American communities was magnified by the apparent economic successes of the Cubans.

Friction between Latinos and African Americans continued throughout the decade. After a Latino police officer was charged with manslaughter in the death of two black men in January 1989, three days of rioting shook the neighborhoods of Overtown and Liberty City. The extremely heightened tensions led to a rare substantive panel discussion between African Americans and Cubans, which took place in Little Havana in February 1989. After a panel presentation on Santeria/Lukumi and slavery, the audience began to express frustration with the state of ethnic relations in the county. Black participants blamed Cubans. "When the Cubans came, the Anglos were so happy they didn't have to deal with us anymore," said a panelist. "Suddenly, there was another 'minority' to receive all the assistance and attention we should have received." The Cuban participants faulted the black community. "The anger of American blacks turns a lot of people off," said a Cuban panelist. "You want me to feel guilty for things I have no business feeling guilty about. Don't tell me about all the abuse inflicted on your people—I had no part of that. Let me get to know you as a person." This type of lack of understanding between the two largest minority groups in Miami had an impact on the development of Little Havana.

Black Cubans arriving via Mariel had their own complaints about racism from earlier-arriving white Cubans. Said one Little Havana local, "We had invented a Cuba in which everyone was white. When the *Marielitos* came, we were forcibly reminded that Cuba is not a white island but largely a black one."

Few non-Latino blacks ventured into Little Havana for employment or entertainment. Cubans and other Latinos often saw the development of Little Havana as a zero sum game, competing with the development of Overtown or Liberty City, both traditionally black communities of the county. City leaders often grouped the geographies of the two minority groups when making policy decisions. Only if a police substation opened in Little Havana, for example, would one be allotted to Overtown or Liberty City.

The Wild West feel of Little Havana during the 1980s and into the next decade was enhanced by the territorial presence of the Latin Kings, a gang originally from Chicago that had expanded its reach to Miami and especially Little Havana. "We ran everything from Jose Marti Park to 17th Avenue, from Northwest 3rd Street to the Roads," said a former Latin Kings member. The dominance of the Latin Kings and the overwhelming presence of the new refugees concerned business owners in the area. Many businesses closed or moved to other areas of the expanding enclave.

Nonetheless, the local arts scene was drawing on new talent, formats and audiences. Teatro Bellas Artes (formerly Teatro Americas) opened in 1983 on Calle Ocho, with Manuel and Mirella Gonzalez as the owners. In 1985, an actor asked if he could use the theater to film a solo he'd been practicing. Peeking inside, Mirella was shocked to see him in a dress and makeup, lip-synching to a female voice. Gonzalez felt inspired to create a *transformista* (drag) show—a musical comedy revue in Spanish. When she announced an audition, seventy men showed up. *Midnight Follies* premiered on Valentine's Day, and the shows remain popular to this day, a Spanish *La Cage aux Folles*. *Transformista* acts became popular in other theaters and music venues in Little Havana, often incorporated into comedy shows and cabarets.

In 1984, the Miami City Commission approved a plan to turn sixty square blocks of Little Havana into a tourist destination: Miami's Latin Quarter. The Planning Department, with Jose Casanova serving as its Little Havana ambassador, created a Latin Quarter Review Board to ensure that all construction and alteration plans conformed to Latin Quarter regulations, which favored brick sidewalks, red barrel tile roofs and sidewalk cafés. The implementation of these policies contributed to giving the Little Havana area its current Latino "feel."

The Quarter was divided into three separate zoning districts, each with a mix of residential and commercial uses, and with one area limited to small, locally owned businesses and corner stores. "What we want is not only tourism," said the executive director of the Little Havana Development Authority. "It's not only a place you visit; you live there." The chair of the Miami Zoning Board, Willy Gort, said that Little Havana already had the "flavor" to attract tourists; it just needed the architecture. Local business leaders formed a Latin Quarter Association and Latin Chamber of Commerce (CAMACOL). The plan included funneling local, state and federal grant funds into the area. Proponents hoped the plan would result in both economic revitalization and cultural preservation.

The co-designation of Ronald Reagan Avenue with Southwest 12th Avenue in Little Havana (then–vice president George Bush is at left), June 18, 1987. *Kiwanis Club of Little Havana Archives.*

The Latin Quarter plan sounded good to many, but it still had to overcome Cuban resistance. To this end, the creation of a Latin Quarter was presented as "essential to preserving as a living monument that area of Little Havana that is the central hub of the exile community in Miami," said architect Willy Bermello, who worked on the Latin Quarter concept with Casanova from its inception. Proponents of the Latin Quarter hoped the incentives would help to create an area with a truly Cuban flavor where residents would live over small shops reminiscent of those in Cuba. In an attempt to institutionalize the "Latino feel" for the Latin Quarter, a proposal was made by the Latin Quarter Association to the county commission in 1987 to rename seventeen streets in the area after Latin American heroes. Even though most of the notables were Cuban (Antonio Maceo, Jose Marti, Maximo Gomez), the plan came under severe criticism for not including women.

Two women (Mariana Grajales and Marta Abreu) were added prior to the proposal's presentation to the county commission. The end result was the

creation of a geographical space that exuded the ideology of exile. Cuban independence heroes like Marti and Maceo and Latin American leaders such as Simón Bolívar and Rubén Darío joined the more contemporary icons of Theodore Roosevelt and Ronald Reagan as fellow travelers along the streets of Miami. Vice President George Bush was recruited to inaugurate the renaming of the Little Havana streets. On June 11, 1987, he stood before a crowd of about three hundred and officially renamed a five-block section of Southwest 12th Avenue as Avenida Ronald W. Reagan.

Despite the creation of the Latin Quarter with the support of local business leaders and city planners, the decade ended with the neighborhood still teetering between renewal and decline. Some changes took place as a result of the Latin Quarter designation. Better sidewalks were installed, and McDonald's was the first area business to conform to the new architectural guidelines by designing its Calle Ocho store in a Mediterranean style. But the grander vision of the Latin Quarter was far from reality. Since January 1985, city planner Jose Casanova had reminded skeptics that over $15 million in private money and $4 million in city and state money had been invested into nearly sixty projects in the neighborhood. Work had ranged from painting façades to repaving streets. "This is just the beginning," he said, emphasizing that the development program would require fifteen to twenty years. "I'd say the foundation of the Latin Quarter has been laid." Still, by 1989, support for the Latin Quarter was hard to muster. The much-anticipated funding to build a multimillion-dollar Latin Quarter Specialty Center across from Domino Park had not received support from state lawmakers. A paltry $400,000 was allotted for the projected endeavor. After almost sixty years of operation, the Tower Theater fell into disrepair and was closed in 1984. Spirits were not running high.

The economic and social development of Little Havana was organized through a series of task forces throughout the decade. In 1983, an East Little Havana Task Force and, ten months later, a West Little Havana Task Force were established to deal with the remainder of the neighborhood. By 1988, a grass-roots movement among the business owners gave rise to the Committee for the Revitalization of Little Havana. Soon after, the city responded to the concerns by establishing a ten-member task force to revitalize the entire area.

On October 10, 1982, Jose Marti Park was dedicated in Little Havana by Mayor Maurice Ferre. He brought with him a small plastic package. "It's a bit of Cuban soil," said Ferre, showing the package to the crowd gathered to see the groundbreaking of the historic park. (October 10 is a Cuban holiday celebrating the Grito de Yara, the beginning of the ten-year war against

Jose Marti Park along the Miami River, 2011. *Corinna Moebius, photographer.*

Spain.) The groundbreaking initiated the $4 million construction of the park, planned since 1973. More than one thousand residents had shown up for public meetings regarding the park, thanks to assistance by organizations such as Centro Mater. An abstract thirty-foot mural celebrating Marti, done by Cuban exile artist Rolando López-Dirube, was unveiled a year after the park's opening. The park was the first major neighborhood development project in East Little Havana.

It almost didn't happen. Now retired Miami city planner Jose Casanova, who had proposed and championed the park since its inception, remembers a doubtful commissioner telling him it would not be built. The area was too bad; it would become a housing project instead. "But what about the future?" Casanova had replied. "We're not going to continue living like this forever! This is a neighborhood. They deserve a park; we have been working on it for many years…This is going to be for the people of the neighborhood. So trust me…we need that park."

In 1990, local preservationist Sallye Jude completed renovation of Little Havana's first bed-and-breakfast in East Little Havana, between the Miami River and the 1st Street Bridge. With six partners, she had bought four decrepit rooming houses, circa 1907 to 1914, hoping to turn them into an inn. Jude was a founding member of the Dade Heritage Trust. Although the

project to restore the buildings began in 1986, it took several years to find the additional investment required to complete the project. It earned a listing in the National Register of Historic Places in 1987.

This project was seen as a gamble, given the poverty that surrounded the investment site and the rate of petty crime nearby. "The location is very good for development," said Manuel Rivero, executive director of the East Little Havana Community Development Corporation, "but the private sector isn't coming into the area because the zoning and the image isn't right." Sallye Jude held on: "It will work if we can hold on long enough for this area to turn around." The Miami River Inn was finally opened in 1990, and Jude and her partner, Magic City Enterprises, won praise from Miami Heritage Conservation Board and added to the growing demand for establishing a unique identity for the entire neighborhood.

A similar success was experienced in the housing market when a new moderate-income complex, Rioplaza, the largest in Little Havana, was 90 percent sold within months of completion. The success motivated other developers to address the housing needs of the East Little Havana residents who increasingly included Nicaraguans as well as Mariel migrants. The East Little Havana Community Development Corporation managed to entice housing developers with a series of local and federal incentives. An eleven-unit town house project was one of the first to take advantage of the incentives, designed to sell to low- and moderate-income residents. In 1988, only 7 percent of the forty thousand residents were homeowners.

In the '80s, one significant loss in historic properties was Ada Merritt Junior High, despite an outcry from teachers, pupils and parents, who campaigned passionately to save the historic school. Ada Merritt was an important gateway to Cubans arriving in the 1960s and then to a more diverse community of Latinos, as it was a pioneer in bilingual education (as was Riverside Elementary, also in Little Havana). Despite their efforts, the building was closed in 1979 and later demolished. The new building finally opened in 2003 but as an elementary school catering to commuters from three counties.

Another school, Miami High, was hanging on; many schools were coping with overcrowding. The second floor of Miami High was nicknamed the "Marielito floor," with the upper floors occupied by more "seasoned" immigrants. By 1981, the student body had transitioned to more than 80 percent Latino. The principal in 1981, Diego Garcia, said that "kids today are still very loyal to the school like their predecessors," but after school they had to "work for six or seven hours and yet they're

Adorers of *La Virgen de Regla* touch the saint's image after it is returned from the procession to the Shrine of Regla, 2011. *Corinna Moebius, photographer.*

the same ones who are packing the place for basketball games and keeping the various clubs full."

New churches were opening up to serve the needs of a transforming neighborhood. In 1975, Iglesia San Lazaro (Saint Lazarus Church) had opened, followed by Iglesia Santa Barbara (Santa Barbara Old Catholic Church) in 1978 and the Ermita de Regla (Shrine of Regla) in 1982. The three namesakes of these Catholic churches—*San Lazaro, Santa Barbara* and *La Virgen de Regla*—are saints syncretized with Orishas (divinities) of the Lukumi/ Santeria faith: Babalu Aye, Chango and Yemaya, respectively. The Shrine of Regla put plaques (one in English, one in Spanish) in front of its building announcing that *La Virgen de Regla* is the "Patroness of Little Havana." All three churches began to lead annual saint processions in area streets, during which devout Catholics and devout Santeros/as walked together. The first of these took place on December 17, 1975, for San Lazaro, the saint of healing and of the downtrodden. In East Little Havana, the Seventh-day Adventist Church recruited new congregants from the recently arrived Nicaraguan refugees it assisted; soon it was better known as Iglesia Adventista del Septimo Dia.

Meanwhile, 8th Street solidified its identity as the heart of Little Havana; Flagler Street slowly deteriorated. The area had never been the same since

Vignette 7: CAMACOL and Its Christmas Giveaway

In 1986, the Little Havana-based Latin Chamber of Commerce, or CAMACOL (*Camara de Comercio Latina*), distributed bags of food to ten needy local families for the first time. Little did the organization realize that its Christmas basket giveaway would become a local tradition, with residents waiting in line as long as a week to receive a free voucher for one of three thousand bags of holiday food.

When the line curves around the corner of his office on West Flagler Street, Luis Cuervo of CAMACOL says, "We go out there and say, 'You can't do this!' They do it anyway. The reason that they do it is because they stand out there, you bring coffee, this guy will bring a soup and share it with everybody out there, they'll play dominos, a guy will come around with guitars. We have a blast."

TV news stations interview people as they wait in the line for vouchers, which are typically distributed the Wednesday after Thanksgiving. Some express hope that with the extra food they can share their holiday meal with a neighbor who has several children to feed; others express relief that their own family can enjoy the meal since they have been laid off from a job or are elderly and coping with a limited income.

Another line forms in the days before the distribution of the meals, which can feed a family of five. The day of the gift bag distribution, hundreds of volunteers participate, including celebrities and elected officials. In 1993, Florida governor Lawton Chiles helped out, accompanied by then gubernatorial candidate Jeb Bush; in 2001, Bush participated again, as Florida's governor. Various companies donate food and services, and the City of Miami also contributes to the event.

Many families eat these meals not on Christmas Day but on Christmas Eve, or *Nochebuena* as is the tradition in Spain and Latin America. In parts of Little Havana, some Cuban families continue the custom of slowly roasting a whole pig on a spit in their backyards (others buy the already prepared *lechón* from butcher shops and grocery stores). Traditionally, father and son travel to a local farm to select the pig. Each family has its own recipe for the *mojo* marinade that gives the *lechón* its flavor; key ingredients are garlic and sour orange.

Some products donated for the CAMACOL Christmas Giveaway come from companies that have built a relationship with CAMACOL through its annual Hemispheric Congress of Latin Chambers of Commerce and Industry, which started as an idea the organization calls "Sanchez to Sanchez to Smith." Cuervo, the current director of the Congress, summarizes it this way: "So it was Sanchez in Latin America, Sanchez in CAMACOL; Smith could've been in Kentucky. Smith wants to buy bananas. He didn't know who to call. So he would say, 'Let's call the Latin Chamber of Commerce.' Latin Chamber of Commerce would get in touch with Sanchez in Ecuador and say, 'I got a guy named Smith, and he wants to buy bananas. Here you go!'"

Although CAMACOL now places most of its program focus on facilitating international commerce, the organization started in 1965 when three Little Havana business owners decided to form a business alliance to address issues of parking in front of their stores. In the mid-1990s, CAMACOL launched a program in Little Havana that provided small business loans of up to $50,000 at 6 percent, payable in five years. Later, it moved to offering a façade program in conjunction with the City of Miami, through which business owners can apply for financial support for improvements like new windows, awnings and so forth.

1977, when a fire—suspected as arson—destroyed ten businesses along a half-block area of Flagler near Southwest 12th Avenue. A City of Miami study of the Flagler Street area between 12th Avenue and the Miami River released in April 1981 pointed to a business decline and dangerously deteriorating housing. In addition to the fire, conditions were spurred by a dramatic population increase since the Mariel boatlift, which led to overcrowding and "severe unemployment, far in excess of the citywide average," one study concluded.

The other iconic site of Little Havana, Domino Park (Antonio Maceo Park until it was renamed Maximo Gomez Park in 1987), attracted its share of attention during this time as well. It was and remains the focus of tourist bus stops and tourist photo opportunities in the area. During the 1980s, visitors would see a gendered and aged world in the park. Dominos were the dominion of men, older men primarily. Tourists would notice and comment on it. "There are no women in the park, not even one," Kwang Suh Hwang said of his visit to Domino Park to the *Miami Herald* in 1982.

In June 1987, Domino Park was closed for renovations, and immediately local business leaders began to lobby to keep it permanently closed. The fate of the park became a divisive neighborhood issue. Many Calle Ocho merchants applauded the closing. "I'm going to do everything in my power to see that the park doesn't reopen," said Luis Sabines, president of the Latin Chamber of Commerce. Sabines said he spoke for area merchants who were tired of warding off "delinquents and drug-sellers" who frequented the park. The business associations were successful in stopping the renovation plans at a June 11 city commission meeting. They claimed that the criminal element at the park was ruining their business and that many would go bankrupt if the park were not closed.

Domino Park had a strong tradition and an active constituency in the community and was the only park along Calle Ocho in Little Havana. The park had become a unique Miami landmark, a picturesque tourist attraction. And increasingly the spectacle of Domino Park was not just for locals. Tourist buses made this their one Little Havana stop, which benefited businesses, at least those close to the park.

Caught between the pleadings of the *viejitos* and the merchants, the City of Miami worked with the nonprofit Kiwanis Club of Little Havana to make Domino Park a retreat for seniors only. The park reopened on September 23, 1988, but only to those with Domino Club identification cards proving they were fifty-five or older. The club also limited the schedule of the park (previously open twenty-four hours a day) to 9:00 a.m. to 6:00 p.m. daily. At the entrance of the newly installed gates, they put a security guard. The park was also renamed for another revolutionary leader, Maximo Gomez, a Dominican general who fought alongside Lieutenant General Antonio Maceo.

Political Culture

During the 1980s, Little Havana was shaped and helped shape the political profile of the Cuban American population in South Florida and the nation. The political culture of Little Havana developed along three dimensions: the electoral, the ideological and the cultural.

During the 1980s, Cubans in Miami began to flex their electoral political power. In 1980, the Cuban American National Foundation (CANF) was created with the help of the Reagan White House. Jorge Mas Canosa, the leader of the organization, realized that it was time for Cubans to begin to

participate in the electoral process to influence foreign policy. Little Havana became the arena for much Cuban political activity, as well as the place that candidates visited when they wanted to appeal to the Cuban vote and where the media went when it wanted to hear what Cubans thought. Of the county's 684,689 voters, 131,778 were Hispanic and 120,018 were black.

In 1982, 26 Cuban Americans registered to run for twelve government posts. This was a record number of Cuban candidates. Some were community activists running for the first time, while others were failed candidates of previous elections. Some traced their lineage back to prominent Cuban exiles. Others were middle-aged Cubans who had tired of waging the eternal underground war against Fidel Castro and had decided to try the political process to achieve the elusive goal of returning to Cuba. "Foreign policy continues to be important. Cuban people are concerned about the events of Cuba like the Jewish people are concerned about the Middle East," said twenty-eight-year-old Lincoln Diaz-Balart, running for the statehouse from the Little Havana District. "But at the same time, they worry about young children's education and transportation of their elderly." In District 113, which included Little Havana, 64 percent of the 22,860 voters were Latinos, mostly Cuban.

The transformation of Lincoln Diaz-Balart from a somewhat liberal Democrat to a staunch Republican is indicative of the spirit of the 1980s. As mentioned earlier, in the 1970s, Cuban Americans registered mostly as Democrats, although the numbers were relatively small. The shift to dominance by the Republican Party took place in the 1980s, during the presidency of Ronald Reagan, thanks to the content of his foreign policy focused on demolishing the "Evil Empire" of the Soviet Union and the creation of the Cuban American National Foundation (CANF). Lincoln Diaz-Balart ran as a Democrat during the 1982 election. He lost to the Republican candidate, a veteran of the Bay of Pigs invasion. Diaz-Balart switched parties in 1985, and in 1992, he became the second Cuban American elected to the U.S. House of Representatives. Cubans in Little Havana, and their foreign policy concerns, had to be addressed during elections. In 1984, Dade's Election Department reported 23,950 registered voters in House District 113, which covers much of Miami's Little Havana neighborhood and a small portion of unincorporated Dade. Nearly 10,000 of the district's 16,000 Latino voters were Republican.

Organizations such as CANF succeeded in the 1980s because of the nationwide shift to the right. Reagan visited Miami four times between 1983 and 1987, dining in Little Havana at La Esquina de Tejas on 12th Avenue and

Southwest 1ˢᵗ Street (which is why Southwest 12ᵗʰ Avenue was renamed after him). He spoke on May 20, the anniversary of Cuba's independence from Spain in 1902 as the result of the Spanish-American War. In 1987, Reagan invited the Brigade 2506 members to the White House to commemorate the twenty-fourth anniversary of the Bay of Pigs invasion. When the Veterans Association inaugurated the Casa de la Brigada 2506, its headquarters and museum in Little Havana, the president sent UN ambassador Jeanne Kirkpatrick as his personal representative.

Ideologically, Little Havana became ground zero for the expression of opposition to all things leftist. When an organization planned or executed an act of opposition directed against the Castro government or any other leftist focus, Little Havana was the site at least for its announcement.

Unlike typical immigrants, exiles were focusing their political agenda on the possibility of return to their homeland rather than on the local issues of their neighborhoods. Perhaps that emphasis explains why Little Havana development strategies languished while anti-communism, the toppling of the Castro regime and the desire to return to a free Cuba never failed to mobilize large swaths of the population. The phenomenon of the "exile ideology" that academics have enjoyed exploring was the rallying cry used to mobilize Cubans in Little Havana. Dozens of organizations emerged in exile, many of them headquartered in Little Havana. The headquarters of the Bay of Pigs invading force, the Brigade 2506, is a block south of 8ᵗʰ Street near 18ᵗʰ Avenue. This focus on Cuba and return shaped the social, economic, political and cultural life of Little Havana. It even shaped the geo-social landscape of the neighborhood.

An institutional example of this type of ethos is represented by Cuban exile organization Los Municipios de Cuba en el Exilio, first founded in 1962 in Little Havana. Prior to the revolution, Cuba was divided into 126 municipalities, and each Cuban belonged to a particular *municipio* simply by residence. The Municipios organization in exile fulfilled a social function, serving as a clearinghouse of information on practical matters facing the growing community, such as housing and employment, and providing directories for Cuban businesses offering services to the community. It also served as the hub of a network of "who's who in exile," helping newly arriving Cubans navigate the obstacles and opportunities awaiting them in the new land. The headquarters of each *municipio* also served as a cultural center, providing recreational activities as well as housing small-scale museums full of photographs and memorabilia of the original *municipio* in Cuba. At the Orange Bowl, Los Municipios held celebratory events during which

every *municipo* had its own booth, and each displayed cuisine and customs traditional to its municipality. Often, the *municipios* also published their own newsletters or newspapers to keep members informed of the happenings, as well as publishing historical remembrances of the homeland. The focus was Cuba. The audience was the Cuban exile in Little Havana.

These understandable expressions of cultural and historic pride shaped the political culture of the community. Unfortunately, there are numerous examples of how ideological motivations can have a negative impact on community dynamics.

In 1983, a powerful pipe bomb exploded in the Little Havana offices of Continental National Bank. One of the officers of the bank was Bernardo Benes. Benes, the bank's vice-chairman, was a Cuban American who angered some South Florida Hispanics by taking an active role in helping initiate talks with Fidel Castro in 1978. Those talks led to the release of more than three thousand political prisoners and to high-level diplomatic discussions between the United States and Cuba. The bombing at the bank was directed at Benes, not at the community work of the first Cuban-owned bank in the United States.

Two other bombings occurred on the night of January 11, 1983—one at Padrón Cigar Factory, three blocks away from the bank at 1566 West Flagler Street, and the other at Paradise International Inc., 1111 Southwest 8th Street. The cigar company owner, Jose Orlando Padrón, also was instrumental in establishing a dialogue between the Cuban diaspora and the government of Cuba. It was at least the fifth bombing of his business since 1979. Paradise International was a travel agency that booked flights to Cuba.

In 1988, controversy erupted around the Cuban Museum of Art and Culture in Little Havana because of the organization's willingness to present the work of artists still living in Cuba. In 1987, the museum sponsored an auction of Cuban art as a fundraising effort. Among the works scheduled to be auctioned in 1988 were paintings by four Cuban artists who had not broken with the Castro regime. The exile media accused board members of being communist sympathizers and began a campaign to force the museum to eliminate the Cuban artists from the event. The event took place including the work of the controversial artists, and a crowd formed outside the museum harassing the seven hundred attendees. One of the controversial paintings, purchased for $500, was burned outside the museum. A few days later, a bomb exploded outside the museum, causing property damage.

Another significant controversy resulting in a black eye for the Cuban community in the eyes of many civil libertarians was the banning from

A protest outside the Cuban Museum of Art and Culture, July 15, 1988. *Greg Lovett, photographer. Miami News Collection, HistoryMiami, 1995-277-1713.*

the Calle Ocho Festival artists accused of being sympathetic to the Cuban government. To be accused of being a sympathizer, an artist did not have to do anything other than perform on the island or refuse to condemn the revolutionary government. Some leaders from within the Cuban community criticized the banning; some called for the Kiwanis to reevaluate their policy.

The *Miami Herald* withdrew its sponsorship for the first time since the festival's inception in 1978, citing concerns over censorship and First Amendment rights violations. In a scathing editorial, the *Miami Herald* called the censorship an "excruciating embarrassment":

> *This is not the old-line exile organization, fueled by 30 years of wrath and forever locked into the anti-Castro struggle to the virtual exclusion of all other issues, but a youthful, motivated club geared to the future. Its members represent, for the most part, the New Miami: ambitious, upscale, well educated, fluently bicultural—yuppies, or Yucas in the vernacular of cultural identification, in their 30s and 40s.*

Cubans were not the only exiles who mobilized politically in Little Havana. More than one thousand Nicaraguan exiles poured into the pews and corners of San Juan Bosco Catholic Church in March 1983 in a religious demonstration against the Sandinista government's scolding of Pope John Paul II because he would not condemn U.S. aggression. In this and many similar protests, the supporters of the Nicaraguan Contras found in Little Havana an area full of fellow travelers. Throughout the conflict, the anti-Sandinista supporters utilized Little Havana as a staging area for protests. In October 1986, two Nicaraguan priests celebrated Mass in San Juan Bosco Catholic Church on Flagler in support of fellow priests in Nicaragua. The same church was the site of the creation of the Coalition for Nicaraguan Civil Rights. The group's main goal was to harness the support of the powerful Cuban community to lobby for Nicaraguans to be recognized by the U.S. government as political refugees who should not be sent back to their homeland. In 1985, Nicaraguan exiles scheduled a march along Calle Ocho to promote unity among the rebel factions fighting the Sandinista government.

The ideological zeal of exiles was also evident in the Little Havana support expressed for Orlando Bosch. Bosch, a Cuban-born physician, was jailed in Venezuela on charges of blowing up a Cuban jetliner in 1976 with seventy-eight persons aboard. Though a prosecutor said that there was no evidence to convict him, a military court maintained jurisdiction over the case, and the government kept Bosch in prison. Acts of solidarity, including Masses and street events, were common in Little Havana until Bosch was released on Friday, August 7, 1987, in Caracas after spending almost eleven years in prison.

The support for Bosch notwithstanding, the actual bomb throwers of the 1970s, once heroes to the Cuban American community, were diminishing in visibility. Eduardo Arocena, head of the once seemingly invincible Omega 7 terrorist organization, was arrested in his Little Havana apartment above the popular restaurant Sorrentos in 1983 and died serving a life term in a California federal prison. Guillermo Novo Sampol, former leader of the violent Cuban Nationalist Movement and once convicted and then acquitted of the murder of former Chilean ambassador Orlando Letelier, was selling advertising air time for a Little Havana radio station. Rolando Otero, the "Mad Bomber" who once planted nine bombs in Miami in one day, was doing thirty years in state prison.

By the end of the decade, the makeup of Little Havana's population had shifted dramatically. Cubans were still living in East Little Havana—those

who had arrived in the '60s, '70s and '80s—but their presence was far less overwhelming than before, as every other neighbor seemed to come from a different country, not just Nicaragua but also Honduras, El Salvador, Guatemala and Colombia.

East Little Havana became the second poorest neighborhood in the city of Miami, behind Overtown, and the most densely populated. The decade saw the rise of two demographic phenomena that still are evident today: the de-Cubanization of large portions of the neighborhood and the neglect of East Little Havana.

Finding a Multiethnic Identity

1990s

Little Havana was an established brand name by the 1990s. The carnival had raised it to national attention, and the incessant political activities of the Cubans kept locals entertained and non-Miamians often perplexed. As the brand name expanded, the identity of the geographic area known as Little Havana became a contested issue, and for that reason, the decade of the 1990s was a critical one for the neighborhood. The deterioration of the 1980s began to slow down, and new challenges emerged. The Latin Quarter project was never embraced by some Cubans, even as the ethnic diversity of the neighborhood became more evident. In 1990, the *New York Times* reported that 350 Cuban Americans "angrily booed" a speech by Cuban American architect Willy A. Bermello, a key proponent of the Latin Quarter project. The mostly working-class, older Cuban crowd again expressed its anger about the name "Latin Quarter," claiming it was part of a plot to "de-Cubanize" the neighborhood. Locals continued to call the area *Pequeña Habana* or "Little Havana" regardless of the new designation or the increasing ethnic diversity of the area.

The disparities between East Little Havana and the western portion of the neighborhood increased. Continuing the trend started by the Mariel migrants in 1980, new, poorer immigrants, now mostly from Central America, continued to use East Little Havana as an entry point to the United States. The influx of new migrants contributed to making the area one of the poorest, most densely populated in the county. East Little Havana was the area with the greatest number of zoning violations. Illegal additions,

An evening soccer game at Riverside Park in East Little Havana, 2011. *Corinna Moebius, photographer.*

garages converted into homes, bedrooms made into efficiencies, collapsing ceilings, apartments wired entirely with extension cords and bare bulbs dangling from exposed wiring were all common violations at the time. Even though rents were lower than in most other sections of the city, new arrivals often created multi-family dwellings out of simple two-bedroom apartments.

In 1990, East Little Havana residents Fernando and Laura Gonzalez founded a new community organization, Vecinos en Acción. They were passionate about assisting and organizing local low-income families at the grass-roots level. Vecinos organized everything from HIV awareness campaigns to graffiti cleanups to group meetings in Jose Marti Park. Vecinos en Acción and Centro Mater, a day-care center for the poor, played a key role in the comeback of the park after it was overrun by gangs. "The park is the lung of the neighborhood. Without it, how can we hope to save the youth?" said Fernando. In later decades, Vecinos also opened a clinic near its office for teen mothers. It became one of the organizations most trusted by the area's most struggling and marginalized residents.

Thousands of new immigrant families settled in East Little Havana during the 1980s and throughout the 1990s as many Cuban families moved to more middle-class areas. The 1990 census figures showed that Nicaraguans and

VIGNETTE 8: BASEBALL

By 1980, baseball teams catering to a Cuban love of the sport were well established in Little Havana. "To the refugees just arriving here, the thought of playing baseball for a living in this country is like a dream," said Ralph Davis, who coached baseball at Miami High for more than twenty-eight years. One student pitcher at Miami High, Alex Gancedo, gave a reason for the involvement: "At most Cuban homes when the men sit around and talk, they talk baseball."

One beloved and well-remembered legend in local baseball is Vicente Lopez, who organized baseball games in Little Havana parks and founded Los Cubanos Libres, a baseball academy that thrived in the '70s and '80s. From the '40s to the '60s in Cuba, Lopez had been a pitcher and star of the Cuban Leagues. As an exile in the United States, he pitched for Miami's Brooklyn Dodgers' farm team, the Sun Sox. In their pivotal game against the Havana Cubans, Lopez helped the Sox win the game 6-1. Then–*Miami*

Vecinos en Acción youth baseball team in Jose Marti Park, 1990s. *Vecinos en Acción.*

Herald sports editor Jimmy Burns called it "the greatest night in Miami's baseball history."

Vicente's career ended abruptly the day after he was set to debut with the Dodgers, who had offered him a contract. He hurt his arm and could no longer play baseball professionally. He ended up in Little Havana, where he dedicated his life to coaching local kids in the game, even in places like Little Havana's Riverside Park and Jose Marti Park when they were overrun by gangs, drug sales and violence.

Another important local baseball coach is Rene Janero, who began coaching kids at Shenandoah Park beginning in 1974. Rene is now in his nineties and is one of the oldest players in Domino Park. In Cuba, he had coached baseball for twelve years; he had also been assistant coach for the Florida State League's Key West team and a trainer for the Houston Astros.

Local organizations like Vecinos en Acción also organized baseball teams and games in local parks. The office of Vecinos en Acción was destroyed in 1997 by a fire. Gone were the uniforms, bats, gloves and baseballs used in the after-school baseball program. The organization moved to a new location but no longer coaches games. Although baseball games are still played in local parks, soccer and basketball are more popular now, a testament to the neighborhood's diversity. The newest place to watch baseball (and sometimes play) in Little Havana is Marlins Park, opened in 2012, its first game between Little Havana's Miami High School and Belen Jesuit.

In 1985, Little Havana was set to be the site for *La Casa de Beisbol* (the House of Baseball). At the meeting where Miami's Zoning Board unanimously approved the museum, two dozen former Cuban stars were part of the audience, including Emilio de Armas, former owner of Cuban clubs Almendares, Marianao, Habana and Santa Clara; and Andres Fleitas, who caught for the Almendares during the 1940s and '50s. The museum was founded in 1939 in Havana but was disbanded in 1961; the Miami-based Federation of Cuban Baseball Players reactivated it in 1983. "Baseball was to us what baseball, football and basketball combined are to the United States," said federation spokesman Tony Pacheco, who played with the Cienfuegos club and Cuban Sugar Kings. Sadly, the plans for a museum fell through.

other Central Americans outnumbered Cubans in many sections of the neighborhood. In one seventy-block area, the number of Hispanic residents of Cuban descent fell by more than 35 percent during the 1980s, the steepest drop for any neighborhood in Dade County. East Little Havana solidified its hold as the Ellis Island for newly arrived working-class immigrants from Latin America.

After a decade in the area, Central Americans and their traditions were having an impact on the culture of Little Havana. New restaurants had opened up to serve this community, and yearly religious festivals like La Griteria also made their impact on local public spaces (see "Vignette 18: La Purisima and La Griteria"). Yambo is still a popular eatery and gathering place for Latin American immigrants, with its own monuments including a bust of Nicaraguan poet Ruben Dario. Nicaraguan president Arnoldo Alemán and legendary contra commander Eden Pastora were known to drop by for meals.

Although a large percentage of the new residents of Little Havana were *mestizo*, few Latino blacks inhabited the area in the 1990s compared to the heavily Dominican northern part of Allapattah, sandwiched between a Cuban neighborhood to the south and an African American neighborhood

A bicyclist riding down Calle Ocho past a hybrid Nicaraguan/Cuban restaurant, Coffee Shop Santa Barbara, circa 1990s. *Hugo Miranda, photographer.*

to the north. Black Latinos complained of discrimination from white Latinos in Little Havana and were more likely to reside where most residents were African Americans or other Caribbean blacks.

In a neighborhood with a housing shortage, on land zoned for higher density, historic bungalows were regularly demolished and replaced by low-rent apartments. The city also encouraged private groups such as the East Little Havana Community Development Corporation to build high-rise condominium buildings.

The few restoration projects that did take place, like the Warner House (which served as office space but is now home to the Miami Hispanic Cultural Arts Center), and the Miami River Inn, a bed-and-breakfast hotel, did not give rise to a historic preservation movement. Instead, the bungalows were regarded as an obstacle to developers wanting to build apartments for young professionals.

The bungalows, built before 1925, received praise for environmentally smart design, characterized by deep front porches, large windows, wide overhangs and use of native materials such as oolitic limestone. They were the dominant residential style in Miami between 1915 and 1925, and the best and largest concentration was found in the old Lawrence Estates subdivision of today's Little Havana.

The historic traditions of Little Havana became contested architectural terrain. On the one hand, some planners wanted the neighborhood to express its historic credentials by renovating buildings to the style in which they were originally constructed. Others wanted to establish a strictly Spanish style consistent with the architectural tropes found in Old Havana. Both sides couched their argument on how to best respect the Cuban presence in the community. Elio Rojas, executive director of the Latin Quarter Association, thought that restoring the Tower Theater to its Art Deco architectural style was a terrible idea. "Art Deco is for Miami Beach, and the beach is the beach. This is the Latin Quarter." What that meant for him and others desiring to maintain an "immigrant" feel in the community was to maintain a Spanish style. Advocates of the Spanish style said that the Latin Quarter architectural guidelines, in place since 1985, honor the Cuban culture best by shaping buildings to look like those in Cuba.

Advocates of the Art Deco restoration argued that the best way to commemorate the Cuban influx was to restore structures to the state in which thousands of Cubans found the neighborhood when they arrived after 1959. When the restoration of the Tower Theater was discussed, Art Deco proponents were particularly adamant. "I wouldn't care if this were a

VIGNETTE 9: CALLE OCHO WALK OF FAME

The Calle Ocho Walk of Fame was launched in 1988 by Javier Soto and his wife, Sara. Soto was inspired by the Hollywood Walk of Fame, where a year earlier, Celia Cruz had received a star. Why not create a Latin version along Calle Ocho, from 12th to 17th Avenues? They founded Latin Stars, Inc. and, after receiving approval from the City of Miami Commission, installed the first star for Gloria Estefan and the Miami Sound Machine in 1999.

A year later, the fifth star was installed, the first to honor a non-Cuban: Spanish singer Raphael. The Little Havana Development Authority and the Latin Chamber of Commerce made nominations for stars. Unfortunately, the nonprofit encountered financial problems, and community members and government officials began a heated debate over who was eligible to receive a star. Only people of Cuban descent? Only Latinos? Only people with a connection to South Florida?

Another moment of controversy arrived in 1991, when an angry crowd of Cuban exiles publicly destroyed the star of Mexican actress Veronica Castro after she visited Cuba. The City of Miami severed all

The Calle Ocho Walk of Fame and former McDonald's building meeting Latin Quarter design guidelines, 2011. *Corinna Moebius, photographer.*

relations with Soto's company that year; commissioners were concerned about the selection process.

Soto was then accused of extorting money from artists eager for their own stars (and even of hiring a hit man to kill a local commissioner), but he was never charged with any offenses and denied them all. It was too much for Latin Stars, Inc., which closed its doors after awarding twenty-three stars.

Another group took over in 1995, with a new company called Stars of Calle Ocho. Its founders, too, were blamed for charging $10,000 (or more) for any entity that wanted a star or for not awarding a star to those whom others thought worthy. For example, in 1997, Spanish pop and crossover singer Enrique Iglesias (at the beginning of his career) was selected for a star, but community members argued that it should have gone to Dr. Ferdie Pacheco. Miami resident Pacheco (aka "The Fight Doctor") was the cornerman for many boxing champions, including world heavyweight champion Muhammad Ali. Pacheco was also a prolific writer and an award-winning artist. After graduating from medical school, he set up his practice in Little Havana.

Some who received stars were not entertainers but local radio personalities and even a popular hairdresser. After 1998, different groups struggled to revive the Walk of Fame project, but it has remained dormant, and in 2012, many stars were lost when McDonald's tore down its building (around which stars had been located) in order to construct a more modernized facility.

Chinese pagoda," said Willy Bermello, the architect of the restoration. "We want to leave this as a memento to remind us of our arrival by freezing it in time." Ultimately, Bermello's argument triumphed, and today the Tower Theater maintains much of its original look.

Other businesses in the area, however, eagerly complied with the zoning guidelines requiring a Mediterranean architectural style. The designers of the McDonald's on Calle Ocho included frame windows in blue ceramic tile and added courtyards. The Latin Quarter Shopping Center has a square tower with a red tile roof. Florida Power & Light paid about $350,000 extra for a Spanish Colonial substation that includes a giant tiled mural of

Havana's La Catedral. Today, many area residences, as well as businesses, do have a Spanish feel, thanks to these changes during the 1990s.

There was always a quaint combination of reality and surrealism in Little Havana during that time. On the one hand, it was one of the few neighborhoods still serviced by a milkman, the kind who went door to door to deliver milk in the mornings to residents. On the other hand, political drama often drew attention to hidden passions of the community. In 1995, two protesters chained themselves to crosses on major crossroads in Little Havana, one protesting contact with Cuba and the other praying for a dialogue between the two countries as the lyrics of the Communist International blared from the speakers in his van. Not infrequently, hunger strikes were waged near Domino Park or in front of the Brigade 2506 memorial in Cuban Memorial Park—both within blocks of a stylish McDonald's—to express solidarity with anti-Castro sentiments and often making demands of the United States.

At the grass-roots level, the emphasis among business leaders and those involved in community development during the 1990s was to somehow stem the deterioration of the neighborhood and establish a tourist-friendly environment. Welcome gates were erected marking the entrance to the Latin

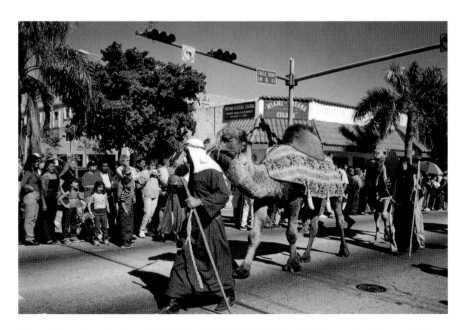

Three Kings Parade along Calle Ocho, 2001. *Pedro A. Figueredo, photographer. Courtesy of the Cuban Heritage Collection, University of Miami Libraries.*

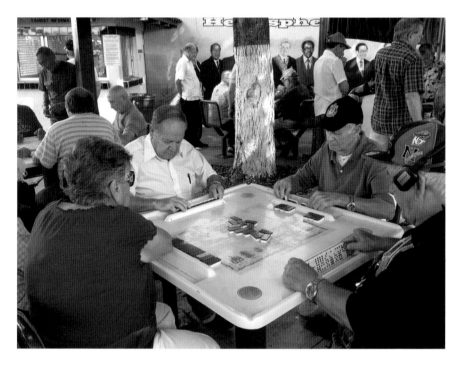

A domino game in Domino Park (Maximo Gomez Park), with the *Summit of Americas* mural on the back wall, 2012. *Corinna Moebius, photographer.*

Quarter by the Little Havana Development Authority. Frequently, volunteer brigades were organized before the Calle Ocho Festival to paint façades and to clean up Calle Ocho to give tourists a "clean place" during the big event. The city renamed two blocks of Little Havana, from Southwest 22nd to 24th Avenues, for Celia Cruz, the famous Cuban singer.

Throughout the 1990s, the city tried desperately to boost tourism in the area and to encourage return visits. In 1995, the city planning department estimated that about 150,000 tourists visited Little Havana each year during the first half of the decade. The first Latin Quarter Arts Festival took place on October 22 of that year at 15th Avenue and Calle Ocho with the hope of spotlighting local art and inspiring visitors to return. How to make Little Havana a tourist destination on par with Miami Beach was always the goal, but the money was not there to advance it much beyond that.

Domino Park (by then renamed Maximo Gomez Park) maintained its distinction as the main tourist attraction of the area. A mural of the thirty-four heads of state invited to the summit was painted on the wall of the park over an earlier mural of domino players in the park, thanks to the computer

VIGNETTE 10: J.C., BERNABE AND THE LATIN KINGS

Growing up in East Little Havana, J.C. was recruited into the Latin Kings, one of the most legendary gangs of Little Havana from the 1970s through the 1990s. Some gangs existed in the late 1970s, but in the 1980s, they flourished. Places like Riverside Park in East Little Havana were filled with graffiti, trash, drug use—and drug sales. Residents were fearful. In 1985, J.C.'s mother died. "It was me against the world," recalls J.C. His aunt, in her seventies and childless, now had the task of raising fifteen-year-old J.C. in an increasingly dangerous neighborhood.

J.C. joined the Latin Kings the same year. "You had to defend yourself! That was one reason I joined a gang in '85," says J.C. "Looking at it in hindsight, some kids lack the discipline at home, and they go to gangs and they find it. It fills a hole, the attention you're not getting at home. For me, it was a sense of belonging," he says. "If I got into a fight, I supposedly had another thirty to forty kids who had my back." J.C. says the Latin Kings gang was born in Chicago in the 1950s. According to

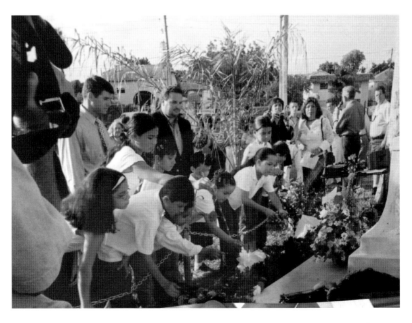

Vecinos en Acción and community members honoring the memory of Bernabe Ramirez at a dedication of his monument in Riverside Park, 1995. *Vecinos en Acción.*

95

the Florida Department of Corrections, it is the oldest Latino street gang in Chicago.

The Latin Kings gang was brought to Miami by "Chino" from Chicago, says J.C., and was run by a man nicknamed Power. Its territory extended from Jose Marti Park to 17th Avenue, from Northwest 3rd Street to the Roads. "Junior gangs" underneath the Latin Kings had their own sub-territories, like the 2nd Street Boys from Northwest.

While J.C. was able to escape the Latin Kings, gangs continued to mark their presence in the '90s, when East Little Havana's Riverside Park was a drug superstore and Latin Kings turf. Gangs had dominated the marijuana trade in the '70s, but beginning in the '80s, they had moved on to selling cocaine. Shabby, neglected apartment buildings fringed the park, and crimes like vandalism and car theft were common.

Tragically, on August 19, 1995, a stray bullet shot during an argument between gang members killed Bernabe Ramirez as he and his mother walked by Riverside Park. Bernabe was just three years old. Locals were outraged, and Bernabe's death was one of the catalysts that led to a large-scale, successful effort between local residents and police to reclaim local parks and public spaces.

Vecinos en Acción erected a memorial for Bernabe in the park, which included a statue of a weeping angel. Sadly, someone stole the statue; a drunk, hammer-wielding man defaced the memorial; and in 2005, the man convicted of killing Bernabe tried to organize a drug deal just steps from Bernabe's memorial, just a year after serving a nine-year sentence in prison for the boy's untimely death.

Riverside Park now hosts softball, basketball and soccer games, and it has a popular playground. Gang activity is not apparent. Some like J.C. who joined (and left) local gangs during the '80s and '90s have found jobs they enjoy and are raising families, but others are in jail, in and out of jail or buried.

work of Oscar Herrera in creating photo reproductions of presidential figures and the painting skills of artist Oscar Thomas in transposing the photos to the wall. The mural served as a reminder that not only had the 1994 Summit of the Americas taken place in Miami, but it had also been organized with the assistance of a Little Havana institution: CAMACOL. As often happens in

Little Havana, the mural is also a political statement. The Cuban heads of state were not invited to the summit, so there is no Fidel and no Cuban flag. Instead, the Cuban coat of arms is visible on one side.

Urban violence, drugs and urban flight continued to plague the area. In 1995, three-year-old Bernabe Ramirez was shot in Riverside Park. His name was immortalized in a statue, inaugurated in 1997, and a street name, Bernabe Ramirez Way, Southwest 8th Avenue between Flagler and 8th Streets.

The year 1994 saw the closing of one of the venerable neighborhood institutions: El Pub Restaurant. In the 1960s and '70s, El Pub came to epitomize the vibrant ethnic flavor of Little Havana. It served as one of the cornerstones of the emerging Cuban identity of Calle Ocho. Local intellectuals, Batistianos, anti-Castro commandos and revolutionaries all ate there—probably at different times but from the same menu. Its closing was significant. Many saw in it signs of the unraveling of the neighborhood, bemoaning the impoverishment and the demographic de-Cubanization of the area. It reopened in 1996, after new owners remodeled it in an old Cuban style.

The decade also saw the first cancellation of Carnaval Miami since its inception in 1978. The 1996 cancellation was prompted by the shooting down of the Brothers to the Rescue planes flying over Cuba on February 24, 1996. Three days later, the Kiwanis Club of Little Havana announced that it was canceling the Carnaval and all its associated activities to mourn the four pilots who lost their lives. Although many sponsors had already contributed to the event, no organization asked for a refund.

Meanwhile, the battle of the Latin Quarter continued to rage. The City of Miami Commission meeting in September 1990 brought out supporters and opponents of the term "Latin Quarter." "When we came here in 1959, there was nothing here," said Manuel Carbon, a protester at the event. "When you say Latin, you're including people from other nations. I don't think that's fair." He and the other protesters wanted the commissioners to strike the phrase "Latin Quarter" and replace it with "Little Havana" on all projects and programs being funded in Little Havana, especially the Latin Quarter Specialty Center, a city-sponsored shopping plaza planned for Calle Ocho, in front of Domino Park. Ultimately, the commission voted in October against dropping the name "Latin Quarter" from city-funded projects.

This ongoing Latin Quarter fight is emblematic of the changes occurring in Little Havana in the 1990s. While the early arrivals climbed the economic ladder and moved out, Little Havana did not lose its identity as the capital of Cuban exiles. Indeed, because the area was undergoing a demographic

transition as Central Americans increased as a proportion of the population, Cubans were on the defensive, and Little Havana increased in its symbolic meaning. Preserving and institutionalizing the name of Little Havana became more important as fewer Cubans actually lived in the area. The feeling of many of the protesters was expressed by one at the second commission meeting: "They intend to take our name away from us, to de-Cubanize the area, and the people deserve respect." Ironically, at the same time, many of the Cubans who had moved from Little Havana described its "lived" community as dangerous, low class and dirty.

Political Culture

Any candidate who wanted to appeal to the Cuban vote had to take into consideration the concerns of Little Havana Cubans, who were still perceived by many candidates as the heart and voice of the Cuban community. In September 1992, Tipper Gore, wife of Democratic vice presidential candidate Al Gore, planned one public appearance in Miami: a rally at Centro Vasco restaurant. She followed in the footsteps of presidential candidate Bill Clinton, who had gone to Little Havana in April 1992 to embrace the so-called Cuban Democracy Act, a controversial bill that was moving through Congress designed to strangle the Cuban government by punishing nations and corporations that trade with Cuba. Elizabeth Dole campaigned as a hopeful *primera esposa* in Little Havana in July 1996, reassuring an elderly crowd that her Republican husband was personally committed to protecting the social-safety net. Dole, on leave from her job as president of the American Red Cross, spent an hour touring the Little Havana Activities and Nutrition Center.

Bill Clinton made a point of visiting the Versailles Restaurant after a fundraiser in Coral Gables during his reelection bid in 1996. Common wisdom had it that if he received around 30 percent of the Cuban vote, he could win Florida. He won the state with approximately 35 percent of the Cuban vote.

Little Havana has always had an asymmetrical, symbiotic relationship with the real Havana. It seemed like the Cuban residents of Little Havana put on their party hats when those in the real Havana were having the hardest times. That type of mood inversion was evident throughout the early 1990s, when Cubans on the island were undergoing the most difficult times since

VIGNETTE 11: CUBAN MEMORIAL PARK

On January 25, 1973, representatives of the Cuban Historical Group Memorial Committee asked the City of Miami Commission to rename 13th Avenue "Memorial Boulevard." The resolution passed unanimously, but soon after the name was amended to "Cuban Memorial Boulevard," reverted back to "Memorial Boulevard" and is now again "Cuban Memorial Boulevard."

The Brigade 2506 monument was the first to mark the park (see "Vignette 3: The Torch of Brigade 2506"). Cuban and U.S. flags were erected on the site by an individual or group unidentified by the city, and in 1975, someone brought these flags to half-staff the day before July 26, violating the federal flag code. July 26 marks the day when Castro and his forces made a successful attack on the Moncada army barracks in 1953, launching the Cuban revolution.

Later monuments included a bronze map of Cuba with an inscription by Jose Marti: "*La patria es agonia y deber*" (The homeland is agony and duty), a life-size statue of Cuban independence leader Lieutenant

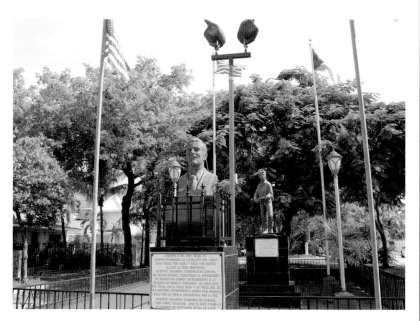

A view of Cuban Memorial Park from behind the Brigade 2506 monument, 2014. *Corinna Moebius, photographer.*

General Antonio Maceo donated by the U.S. Veterans of Foreign Wars in 1975 and a statue dedicated to motherhood donated to the city in 1957 by Cuba's oldest Masonic order and later moved in front of the ceiba tree in the park.

Then and now, many area residents treated the large ceiba, with its massive, aboveground root system, with special reverence. Especially important in Afro-Cuban spiritual traditions like Lukumi/Santeria and Palo, the tree remains a site where offerings are laid, from fruits and candles to sacrificed chickens.

In 1982, Cuban artist Ana Mendieta created an artwork on the tree (*Ceiba Fetish*) using a paste made from women's hair she collected from nearby barbershops, as well as her own hair. She used the paste to draw her silhouette and three oval circles on the tree. Lukumi/Santeria held a great fascination for Mendieta, considered Cuba's most famous female contemporary artist, but she was not an initiated practitioner of the religion. Adherents accused her of desecrating the tree. "You don't play with a ceiba," said Digna Garcia, a Santera at the nearby *botanica* La Negra Francisca, across from the park. Three years later, Mendieta fell from the thirty-fourth-floor window of her husband's apartment in Manhattan, and though he was tried for murder, he was found not guilty. She was thirty-six.

Soon after, in 1984, anti-Castro organization Acción Cubana asked the City of Miami for permission to donate a statue to the park designed by sculptor Tony Lopez. They wanted to honor Nestor "Tony" Izquierdo, a Bay of Pigs veteran credited with making nineteen clandestine sabotage raids on Cuba and with advising then-Nicaraguan leader Anastasio Somoza's National Guard. At least two historians claim that Izquierdo was the Dal-Tex spotter in the assassination of President John F. Kennedy. The statue was finally completed in 1991. Acción Cubana still considers this and other portions of the park its private property; in 2012, it offered to donate the space to the Republican Party for events.

By the late 1980s, the park was in serious disrepair due to vandalism and neglect. Vandals destroyed the statue of Antonio Maceo, and many other monuments were spray painted with graffiti. Homeless people slept and drank in the park. "There is nothing easy about this land of liberty," said one of them. Finally, in 1989, the park received a belated

face-lift by city employees (a decade later, Friends of Little Havana took a special interest in maintenance of and upgrades to the park). Sponsors agreed to pay for the replacement of the Maceo statue with a bronze bust made by Tony Lopez (finally installed in 1995). Most later monuments honored those who fought against Fidel Castro and his government, either by pen or by sword.

In 1996, a group of Mendieta's admirers held a candlelight ceremony for her at the ceiba, where her silhouette remains. Ileana Fuentes, who served as director of Little Havana's Cuban Museum of Art and Culture, calls the ceiba the park's most significant monument. "Unfortunately, all of the official symbols that are placed there are symbolic only of certain struggles of the Cuban exile community," she said. "The tree stands there in its natural order surrounded by all this war-mongering paraphernalia. If the tree were asked, 'Do you want these things here?' she would probably say, 'No, don't bring me these symbols of people's inabilities to resolve things peacefully.'"

the beginning of the revolution due to the collapse of the Soviet Union. *El Periodo Especial*, they called it (the Special Period). In Little Havana, the time was a special one as well. Hardly a week went by without a solidarity march designed to encourage support for an overthrow of the government on the island. Hardly a week went by without local leaders and politicians expressing their belief that the clock had run out on the Castro brothers and that the Miami Cubans would become significant in the envisioned transition to democracy. Jorge Mas Canosa, the charismatic leader of the Cuban American National Foundation, was covered on *60 Minutes*, and he let the world know that he was a man of action and that "if the best way to serve Cuba" was to be its next president, he was willing and able.

At the street level, there was enthusiasm for the anticipated "fall." On October 9, 1993, commemorating the symbolic rise of the nineteenth-century Cubans against their colonial masters in the *Grito de Yara*, a massive demonstration called the March of Unity to Support the Cuban Rebellion amassed thousands along the streets of Little Havana, starting at the Bay of Pigs monument of the 2506 Brigade (Cuban Memorial Plaza). Local and national political leaders joined the dozens of clubs and organizations encouraging the citizens and armed forces of Cuba to rebel against the

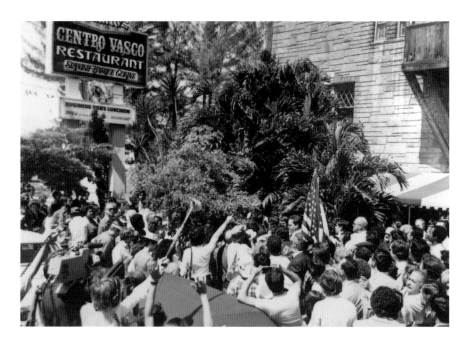

Protesters outside Centro Vasco angry about a scheduled performer thought to be "soft" on Castro; Centro Vasco was bombed shortly thereafter, 1996. *Kiwanis Club of Little Havana Archive.*

government. Said Roberto Rodriguez Aragon, president of the Cuban Patriotic Junta, an exile group involved in organizing the march, "We believe that the situation in Cuba is so critical that it could lead at any moment to a total rebellion by the army and the people. The march will be a message of exile solidarity with the people of Cuba." Many businesses in Little Havana closed early to participate in the event.

The Cuban crisis sparked an increase in armed militancy among some sectors of the Cuban American community. The headquarters of the Brigade 2506 in Little Havana served as a staging area for militant organizations to recruit new blood. Leaders of paramilitary groups found new motivations among the young, newly arrived men to join their cause. A 1994 news article reported that recruits to join paramilitary exile groups were increasing due to the crisis in Cuba. Sergio Gonzalez Rosquete—leader of the National Democratic Unity Party, a commando group known as PUND—reported that more than 150 exiles signed up for PUND commando training in the first three weeks of January of that year.

The second half of the decade was dominated by another type of protest. Little Havana was used as a stage to complain about Washington's changes

to the three-decades-long Cuban Adjustment Act and to express vehement opposition to any kind of rapprochement with the island government. Exiles walked in a rainy-season downpour on October 15, 1995, down 8th Street in support of the Helms-Burton Act, which would tighten the U.S. economic embargo against Cuba and which they suspected Clinton would veto (he did not). On December 6, 1997, a March of Patriotic Reaffirmation' took place to "reiterate the community's rejection of any kind of agreement or deal with the tyranny" and "to oppose the so-called Pilgrim's Cruise [to Havana in January, on the occasion of Pope John Paul II's visit], which is a weapon that undermines the steadfast position of the Cuban exile community." And again they marched in 1998 in opposition to a bill that would allow American companies selling medicine and food to deal directly with the island government.

Other spontaneous and planned events mobilized the streets of Little Havana during the decade. The 1990s began with a valiant attempt by organizers to establish a human chain of protesters from Little Havana to Key West to express solidarity with the people of Cuba just ninety miles away from where the chain would end. Organizers had projected that up to 350,000 people would populate the chain, but on February 24, 1990, an estimated 22,000 people were present to stretch the chain from the Bay of Pigs monument in Little Havana to Mallory Square in Key West. Although there were many gaps in the chain, symbolic solidarity was expressed with the Grand Havana in Cuba, and not without hyperbole. "It's a big success. It has surpassed all the expectations we had for this event," said its lead organizer. "Fidel Castro will definitely be aware of this, and he will shake."

A year later, more than twenty thousand people turned out in Little Havana for a march originally billed as a call for democracy in Cuba but that grew to include support for U.S. troops in the Persian Gulf. The March of a United People was coordinated by dozens of Cuban exile organizations, but fellow travelers often participated in these types of rallies. The last group in the march was the Miami Lithuanian-American Club. "We're out here to show solidarity with the Cubans who are also fighting the same things we're fighting—the oppression of Communism," said Uytas Dubauskas, a director of the club.

The ideology of exile continued to be institutionalized in the street names of Little Havana in the 1990s. Portions of Southwest 9th Street between 17th and 22nd Avenues were renamed Brigade 2506 Way after the liberation force that foundered at the Bay of Pigs in 1961. An intersection of West Flagler Street in Little Havana was renamed in honor of the late anti-Castro

Vignette 12: Fighting to Stay—Central Americans in Little Havana

By the late 1970s, an estimated ten to twelve thousand Nicaraguans were seeking political asylum in Miami, desperate to escape years of war and the economic devastation caused by it. The fall of the Somoza regime in Nicaragua and later the Contra War unleashed a flood of refugees seeking political asylum. Central American immigrants waited for asylum and residence papers, dreading the prison-like Krome detention center or deportation. Many became innocent victims of schemes masquerading as "immigration counseling," often offered at offices in Little Havana. One such business was run by Cuban exile Carlos Sigler, whose clients (including other Cubans) paid him thousands of dollars before he disappeared with their money.

By 1987, it was relatively easy for Nicaraguans and other refugees to receive work permits while the INS determined whether there was a "well-founded fear of persecution" if they returned to their homeland.

Miami immigration reform campaigners alongside the stage at Calle Ocho Festival, 2013. *Corinna Moebius, photographer.*

In late 1988, however, the INS announced it would speed up the review process and also stop granting preliminary work permits to political asylum applicants until the process was completed. Business owners were concerned since they could not legally hire workers lacking work permits, and unemployment soared. On New Year's Day 1989, more than one thousand Nicaraguans in exile protested the decision with a march along Little Havana streets.

On November 19, 1997, President Bill Clinton signed the Nicaraguan and Central American Relief Act (NACARA). It enabled thousands to obtain permanent residence, halted deportations and resulted in a number of Nicaraguan restaurants and other businesses opening soon afterward.

The following year, rainfall caused by Hurricane Mitch left millions homeless in Honduras and Nicaragua. Central Americans in Little Havana and other parts of Miami desperately wanted to go back to help friends and family in their homelands, but doing so would mean jeopardizing their immigration status in the United States. Under a 1996 law, if immigrants who arrived in the United States illegally leave the country before their immigration status is finalized, they are prohibited from returning to the United States for up to ten years. At the Florida Immigrant Advocacy Center in Little Havana, immigrants shared their sad stories.

Undocumented Hondurans and Nicaraguans received the good news that they would have some extra time to apply for Temporary Protective Status (TPS)—under which they could stay in this country and work without fear of being deported—when the Immigration and Naturalization Service extended the deadline forty-five days in July 1999. The party was in the streets of Little Havana.

Central Americans were again anxious in 2006 after the U.S. Department of Homeland Security ended TPS for certain refugees from particular countries in crisis; they worried that the programs for Central Americans would be ended, too. Thousands visited the Little Havana offices of Honduran Unity to sign a letter to President Bush urging him to extend the program. The Honduran-born director, Jose Lagos, had become a local hero for his tireless advocacy on behalf of local immigrants. Miami's three Cuban American lawmakers—Representatives Ileana Ros-Lehtinen and Lincoln and Mario Diaz-Balart—also wrote in support. The program was extended.

> Immigrants continue to battle for legal status, using the services of organizations based in Little Havana and elsewhere, but now their children are also using virtual tools like Facebook and Twitter for activism.

militant Tony Cuesta. As the leader of the Miami-based militant group Comandos L, Cuesta conducted numerous covert operations against the Cuban government.

Cubans were not the only ones who used the streets of Little Havana as a stage for political drama. Panamanian president Guillermo Endara started his five-day U.S. trip by attending Mass at San Juan Bosco Roman Catholic Church in Little Havana. In 1990, Nicaraguan exiles also expressed concern for their country in Little Havana. On February 25, 1990, elections were held in Nicaragua. Supporters of both sides called Miami home, but the voices that used the bullhorn of Little Havana were the supporters of the opposition, those who considered themselves exiles from the revolutionary Sandinista government.

During the first few months of 1994, there were a number of dramatic and violent incidents as Cubans seeking to leave the island crashed into embassies; commandeered planes, helicopters and boats to the United States; and departed in makeshift rafts. These unauthorized departures resulted in a tragedy when a Cuban government vessel attempted to stop a hijacked tugboat and more than forty of its occupants drowned, including children. Another hijacking resulted in the death of a Cuban police officer. Rafter (*balsero*) rescues at sea or landings somewhere on the Florida coast increased as the crisis became more pronounced. According to the U.S. Coast Guard, only 47 rafters were reported in 1983, while 2,557 were picked up in 1992; in 1993, as of October, the number was 2,404.

The Cuban government responded by reopening the migration stream, announcing on August 11, 1994, that it would not detain anyone trying to leave Cuba in a raft or other vessel. As a result, nearly thirty-seven thousand Cubans were rescued at sea by the U.S. Coast Guard in less than a month. The bulk of the arrivals were detained for more than a year in camps at the U.S. naval base in Guantánamo. Remembering the Mariel experience, the United States was unwilling this time to hold the door open for Cubans. The absence of alternative destinations for the rafters, however, as well as

the deteriorating conditions in the camps, eventually prompted the United States to admit them into the country.

The rafter crisis of 1994 was halted after only one month when negotiations between the two countries resulted in an agreement whereby the United States committed to admit at least twenty thousand Cubans a year through the normal visa process. For their part, the Cubans agreed to accept the return of any future unauthorized emigrants interdicted by the U.S. Coast Guard before reaching U.S. shores. The immigration agreement resulted in the change to the Cuban Adjustment Act (CAA) known as the wet foot/dry foot policy: if Cubans make it to dry land in the United States, they are allowed the benefits of the CAA. If they are intercepted at sea or fail to make landfall, they are returned to the island.

Little Havana received migrants through several refugee processing centers and, eventually, as new residents. The impact of the intensity of the flow was captured by Michael Castlen, a service provider at the Church World Service refugee processing center in Little Havana: "After the Mariel boatlift, we were down to two or three staffers. Last year the office increased

A street procession for Santa Barbara passing by the Tower Theater on Calle Ocho, 2012. *Corinna Moebius, photographer.*

its staff to about 25 to handle the increasing number of refugees from Cuba and Haiti."

The Cuban Museum of Art and Culture continued to attract more than its share of drama and controversy. While it had established itself as the foremost promoter of Cuban art in Miami, the museum once again became the target for a terrorist's bomb in June 1990. The attack was the sixteenth such act in Little Havana and Miami in general since May 1987 against persons perceived as favoring better relations with Cuba.

The relevance of the museum grew, however, as it continued to be the foremost promoter of Cuban art in Miami, regularly including artists from Cuba and the diaspora in its exhibits. In 1993, it provided a forum for female Cuban artists, *de aqui y de alla* (from here and there), that received outstanding reviews and brought attention to Little Havana's art scene.

But intolerance was all too often tolerated. In 1992, three men broke into WOCN-Union Radio, a Little Havana radio station that broadcasts programs advocating improved relations with Cuba, and beat and tied up one of the employees; they damaged some of the equipment before fleeing. Francisco Aruca, a well-known community activist and businessman whose *Radio Progreso* program advocates improved relations with Cuba, suggested that the break-in was politically motivated. Aruca said the suspects were looking for him.

The 1990s also saw the passing of one of the most significant figures in the history of Little Havana and the Cuban exile community: Jorge Mas Canosa (1939–1997). The founder of the Cuban American National Foundation was buried in Woodlawn Cemetery on November 25, 1997. Even longtime critics of the man and his positions voiced their regrets. Francisco Aruca, a critic of many of the views of the CANF and its founder, expressed his condolences to the Mas family and cut off any callers to his open-mic radio show who attempted to speak badly of the late exile leader. Thousands of Cubans attended the Mass at St. Michael's Church on Flagler.

By the end of the decade, renovation and the good life still eluded Little Havana, despite all the work done by activists and city planners. The Tower Theater was still being renovated, although the first phase was completed in late 1998. Plans abounded for revitalization, but the reality lagged behind. It seemed an area stuck in the past, politically and economically. Crime was still a problem for residents and business owners, particularly along Flagler Street and in East Little Havana. The distinction between the east/north and the south/west remained, and the Cuban "identity" of the area often conflicted with the demographic realities. Even in its Cuban-ness, the neighborhood

VIGNETTE 13:
BOTANICAS AND AFRO-CUBAN SPIRITUAL TRADITIONS

Lukumi, Lucumi or Regla de Ocha—more widely known as Santeria—is an Afro-Cuban religion practiced around the world, with more practitioners in Miami than in any other city in the United States. The popularity of this spiritual tradition in Little Havana is evidenced by dozens of *botanicas* dotting the neighborhood. Practitioners include people of all ethnic backgrounds, although most are of Cuban descent.

The religion emerged in Cuba as many thousands of enslaved Africans were brought to the island during the late eighteenth and nineteenth centuries, most from Yorubaland kingdoms that are now southeastern Nigeria and eastern Benin. Although forbidden to practice the traditions of their ancestors, they masked their Orishas (divinities) by associating each one with a Catholic saint. Practitioners

Ezequiel Torres (left) with son Aruan Torres (right) finishing a handmade *batá* drum, 2010. *Corinna Moebius, photographer.*

also integrated practices from other African and non-African ethnic groups in Cuba. Even Cubans of wealth and influence developed respect and belief in the spiritual potency of these practices, which had a significant impact on the development of Cuban popular culture, from music to dance, visual arts to storytelling.

In Miami and other cities, a new kind of shop emerged to meet the needs of Cuban and other immigrants seeking items related to Lukumi/Santeria, as well as Palo, Espiritismo and Curandismo. *Botanicas* carry these items, like candles, incense, sacred plants and religious necklaces. *Botanica* owners often give spiritual consultations in their space.

In Little Havana, the number of *botanicas* grew after 1980, when the Mariel boatlift brought many additional practitioners to Miami. Some of these early *botanicas* were Almacen Felix Gonzalez (which sold among its large collection life-size statues of saints associated with particular Orishas), Botanica Nena and Botanica Negra Francisca. People used word of mouth to find religious drummings (such as *tambors* or *guiros*) held in private homes or rented event halls. Non-Cubans who learned about Afro-Cuban religious traditions often labeled them witchcraft and black magic, and early Cuban arrivals sometimes borrowed these terms in order to disassociate themselves from the stigmatized practices.

The '80s also brought talented religious artisans, musicians and dancers into Little Havana, and along with Santera/os and Babalawos (priests), they composed an informal economy. One of these musicians and artisans is Olubatá Ezequiel Torres. Torres began making the *batá* drums (a set of three double-headed, hourglass-shaped drums) and other percussion instruments soon after relocating to Miami. He earned a reputation as one of the finest drummers and drum-makers in the United States and still makes and teaches *batá* drums at his home in Little Havana. In 2008, he received a National Heritage Fellowship from the National Endowment of the Arts, the highest award given to traditional artisans in the country.

The last two decades have seen a surge in sacred music and dance being performed as "folklore" in art galleries, music clubs, theaters and events like the monthly Viernes Culturales festival. In 2013, CubaOcho celebrated Cuba's patron saint—La Virgen de la Caridad

del Cobre—in an evening that included not only Cuban *son* music but also a performance of dances, songs and drumming for Ochun, the Orisha syncretized with La Caridad. The owner said, in Spanish, "It is time we honor and recognize, as Cubans, our African roots. Tonight we celebrate not only La Caridad del Cobre but also Ochun."

expressed an ambivalent identity. The "new" Cubans had little in common with the "old" migrants. The Cuba that the new arrivals left had little in common with the Cuba discussed by the old-timers at Domino Park or the Cuba that spurred marches and outrage because a Castro was at the helm. As a recent arrival reported, "Castro meant nothing to us back then. Life was hard in the '90s [in Cuba]. We wanted out."

The Little Havana entering the new millennium was like a cemetery, if you ask *el poeta* of Little Havana, Eddy Campa. In 1999, he published his first book of poems, *Little Havana Memorial Park*. The source of his inspiration for the book was the decaying swath of Southwest 8th Avenue and 4th Street alongside Riverside Park and its people. This is not the Little Havana of the Versailles Restaurant, where the middle class frolics after a late-night gala affair and the hopelessly hopeful debate the overthrow of Fidel Castro. This is not the Little Havana of Cuban radio politics and of eyes scanning the horizon for changes on the island. Campa came during Mariel and had lived in Tent City. "I no longer remember the days in Cuba,'" he said. "It's logical, the normal process of the mind." But he lived in Little Havana, after a few years of homelessness, and this is the world he knew. He looked at his barrio of Central American immigrants and Cuban exiles "in an artistic form." "These aren't people who lost it," he said in an interview for the *Miami New Times*. "They just never had it. It's not the story of those who haven't triumphed. It's the story of those who can't triumph."

The cracked sidewalks, the carcasses of old cars, the coffee-stained countertops became his writing desks. He wrote and rewrote his poems on toilet paper, on discarded Medicaid forms, on flyers advertising cheap meat. He wrote about Little Havana as it was. Not as city planners saw it or as Cuban patriots would want it, but as it was and why it remained an emotional core for immigrants of all stripes.

Todos, todos estamos en Memorial Park.	*All of us, all are in Memorial Park*
¡Como nos vemos obligados a revivir	*We are so compelled to relive*
en este cementerio las alegrías	*In this cemetery, the joys*
y las tristezas de Little Havana!	*And the sadness of Little Havana!*

Chapter 6

On Renaissance and Other Stories

2000–2010

Everything has its moment, and Calle Ocho's finally arrived.
—*Tony Wagner, director of the Latin Quarter Cultural Center,*
February 18, 2001

The new millennium ushered in an unprecedented period of rejuvenation for Little Havana and its main artery, Calle Ocho. This was the decade of a cultural renaissance, during which artists and intellectuals from the Mariel, as well as older and more recent arrivals from Cuba/Latin America and young Latinos, were all collaborating in new ways, bringing an open, edgy and bohemian spirit to the area—but one that in later years struggled to stay alive.

Residents of East Little Havana weren't so quick to move outside the neighborhood; some had grown to love their *barrio*, including homeowners. Cubans and Central Americans were marrying one another or, in the very least, chatting with their neighbors and forming friendships. People from outside the neighborhood started to visit it again—and some were moving back. Over the course of the decade, but especially after the Elián González affair, locals began to share their political points of view more openly, without fear of shouting matches or retribution. Local venues even dared to invite groups from Cuba to perform.

The 1995 immigration agreement with Cuba regularized immigration from the island at over twenty thousand arrivals per year, and many of the new residents began their journey in the new land on the almost sacred

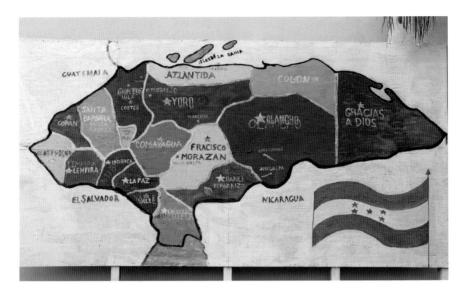

A map of Honduras outside Los Paisanos (Honduran restaurant) in East Little Havana, 2011. *Corinna Moebius, photographer.*

ground where their compatriots had established roots over forty years earlier. Demographically, the area continued its diversification, but the de-Cubanization trend was slowed.

The 2000 census was a mixed bag for Miami and Little Havana. Miami-Dade County's signature city was the second-largest city in Florida, at 362,470, behind Jacksonville. Little Havana was gaining residents and remained one of the densest areas in the city, particularly the East Little Havana section. The tracts composing Little Havana counted 54,646 residents; 79 percent of this population was foreign-born, and 92 percent was Latino. Cuban-born immigrants made up less than half—47 percent—of the Latino population, followed by over one-quarter of residents (26 percent) hailing from Central America (primarily Nicaragua and Honduras). A small but growing number of residents was from South America. A notable portion (18 percent) did not identify primarily by national origin but rather as "other Hispanic or Latino." Survey data from 2005 showed that the Latino composition of Little Havana continued to grow as a proportion of the overall population, climbing to 96 percent. Cuban-born immigrants remained the largest foreign-born population of Little Havana. Thus, Little Havana could most accurately be described as a multi-ethnic Latino neighborhood where the historic demographic dominance of one ancestry group—Cubans—was diminishing.

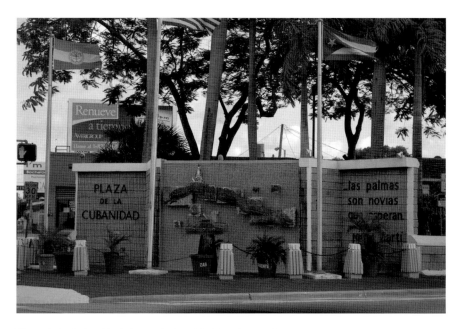

Plaza de la Cubanidad, 2011. *Corinna Moebius, photographer.*

The overall economic profile of Little Havana shows it to be, still, a poor neighborhood set in a poor city. To put Little Havana in perspective, the median household income in 2000 was lower than the median for Miami: $19,957 versus $23,314. For several years in a row in the early 2000s, Miami was the poorest of large cities in the United States, and as of late 2007, Miami ranked third. Despite millions of dollars invested in affordable housing for Little Havana, few units had actually been built, as documented in the Pulitzer Prize–winning series "House of Lies" (2007) in the *Miami Herald*. One of the agencies accused of not building promised units was the East Little Havana Community Development Corporation.

Gentrification of the area also began in earnest. The average price of single-family homes in East Little Havana increased from about $92,000 in 2000 to almost $270,000 by 2005. Median monthly rent grew from about $476 in 2000 to $766 in 2010, a 61 percent increase. In 2006, one-bedroom apartments were advertised starting at $203,000.

As the neighborhood redeveloped, Cuban heritage continued to be the focus of the urban landscape. The construction of Jose Marti Park in the 1970s and Plaza de la Cubanidad in the 1980s, along with the completion of most of Cuban Memorial Park in the 1980s, were the foundation stones of a cultural identity associated with the neighborhood. Jose Marti Park is a

significant symbolic marker of the community. The park is located at the eastern edge of Little Havana along the Miami River's decaying industrial district with a view of downtown's high-rising skyline. The park took its present form in 2001 through a multimillion-dollar expansion of facilities and programming to serve local residents. In 2008, the city hired celebrity architect Ben Zyscovich and his company to design an $11.3 million gymnasium.

The differentiation between the south/western section of the neighborhood and its north/eastern blocks was still stark and could be seen by simply driving down Calle Ocho or West Flagler Street. Local residents like Marta Laura Zayas, founder of the Friends of Little Havana Facebook group, complained that West Little Havana also suffered from neglect. Despite years of attempting to revitalize the area, development had been uneven at best. The entire neighborhood had benefited somewhat from improved sanitation, safety and infrastructure, but the stretch between 12th and 17th Avenues on Calle Ocho had clearly become the most visible economic core and the place that expressed nostalgia through its monuments, parks and—eventually—souvenirs. Local business leaders envisioned it as a tourist district.

Nonetheless, in 2010, the Latin Quarter zoning overlay ended with the implementation of Miami 21, a new form-based code for the city. Soon afterward, the once Mediterranean-style McDonald's on Calle Ocho was demolished and replaced by a McDonald's one might see anywhere; the Little Havana Merchant Alliance persuaded the owners to put murals by local artists on its outdoor walls.

The businesses that resided beyond the Calle Ocho core did not reap the benefits of the many development plans that focused on the main stretch. In 2002, *Miami Herald* columnist Daniel Shoer Roth wrote, "The stretch of Calle Ocho between 12th and 17th Avenues has become the area's cultural, economic and social enclave, while—to the east and west—the revitalization of the neighboring blocks has lagged behind." He quoted the owner of a beauty salon on the eastern side of Southwest 12th Avenue: "Revitalization has not reached here. This part has been forgotten." Meanwhile, in the tourist district, police on foot and mounted patrols were vigilant about keeping the area clear of homeless individuals, drug use and public drinking, and their presence was meant to help deter crime. The East Little Havana Neighborhood Enhancement Team (NET), and especially its charismatic director, Pablo Canton (whom some called "Mayor of Little Havana"), worked closely with the police and other agencies but also served as a watchdog for code compliance.

VIGNETTE 14: THE MOUNTED PATROL

A Little Havana legend is Officer Manny Gomez and his horse, Prince, who together patrolled Calle Ocho beginning in 1990. Frog Prince (his full name) received royal treatment at particular cafeterias; he loved buttered Cuban bread. One merchant put up a sign declaring Calle Ocho "Home of Frog Prince, City of Miami Police Horse." Some businesses had the equivalent of hitching posts so Prince could wait outside, and one local remembers seeing the pair gallop down Calle Ocho to catch a criminal.

In two years, Gomez made 247 arrests and issued 370 traffic tickets and 2,526 parking tickets. The pair also received twenty-five commendations. The back of an early tourist information booth on Calle Ocho has an image of Gomez standing next to Prince. In 2006, however, Gomez suffered a dramatic fall from his police horse and bruised his spinal cord so severely that some thought he'd never walk

Mounted Police Officer Eduardo Perez and his horse Panchito stand outside Los Pinareños *fruteria* (Guillermina Hernandez is behind the counter), 2012. *Corinna Moebius, photographer.*

again. On the day of the fall, his usual horse was sick, and the replacement horse jerked suddenly as Gomez was mounting him, flipping the officer back onto his head. "I thought that was it for me," said Gomez.

In the emergency room, doctors tried a procedure they had not attempted before, and it worked to prevent the injury from worsening. With physical therapy, he walked again but did not return to the mounted patrol.

After 2010, Miami police officer Eduardo Pérez became the new officer on horseback for Calle Ocho. Locals quickly nicknamed his horse Panchito. Perez catches criminals, but he is also known for greeting people warmly on the street and blocking traffic so people can cross the street safely. In gratitude, one local woman gives Perez three cut apples and three peppermint candies to give to Panchito every day.

Now-retired East Little Havana NET administrator Pablo Canton standing next to the Cuban American rooster at Southwest 16th Avenue and Calle Ocho, 2012. *Corinna Moebius, photographer.*

Many of the businesses within the 13th to 17th block stretch started to cater their businesses more toward tourists. The Calle Ocho Chamber of Commerce distributed free brochures about the neighborhood; one business owner started selling ad space for maps of the area. Rooster sculptures were installed on local street corners. In 2002, the Miami-Dade Empowerment Trust bought eight five-foot rooster sculptures based on a model designed by Tony Lopez. Lopez had a pet rooster, Pepe, that followed him around protectively until the day Lopez died in 2011. According to local artist Pedro Damian, Lopez made nine roosters from his mold, and sculptor Ramon Lagos and Lazaro Valdez designed molds used for an additional eighty-two sculptures. Each of the original seventy-pound fiberglass sculptures (designed by Lopez) was painted and decorated, with inexpensive crystal balls for eyes.

Unfortunately, a rumor spread that the police had placed hidden cameras in the eyes of the roosters. The roosters were defaced and vandalized and their eyes removed, and gang members were blamed. Eventually, new roosters were installed on the sidewalks, with additional roosters purchased by business owners. Pablo Canton, director of the East Little Havana NET, continued to help maintain and repair the roosters as needed, even repainting those that needed touch-ups.

Little Havana's Arts Movement

Something was changing in Little Havana, and it was driven in many ways by the sons and daughters of immigrants and exiles mingling with Cubans who were tired of political battles. Unafraid of the consequences for their openness, these artists were mixing everything up and crossing every boundary that had been so vigilantly protected before.

At the beginning of the millennium, Viernes Culturales (Cultural Fridays) brought even more attention to this long-percolating local arts scene. The idea for Viernes Culturales emerged in 1999 from an arts exhibit with live performances at Dr. Rafael A. Peñalver Clinic (Clinica Peñalver) in East Little Havana, at 971 Northwest 2nd Street. Sergio Fiallo, then executive director of the clinic, came up with the idea for the festival as part of an anti-obesity health, fitness and arts program called Padres 2000 developed by the University of Miami. Children were encouraged to create artworks based on their predictions for the millennium, and the works were exhibited

A performance on the stage at Viernes Culturales, 2008. *Courtesy of Viernes Culturales/Cultural Fridays, Inc.*

in the clinic's courtyard and second floor. Every outdoor space facing the courtyard was filled with art.

In 1999, the clinic had begun offering cultural nights with performances and exhibits that often had a health-related theme and were aimed at helping the area's low-income residents learn how to prevent HIV/AIDS and control stress. These events spurred the creation of Little Havana's famous monthly Viernes Culturales festival. Commissioner Joe Sanchez and other local leaders decided the idea was worth bringing to Calle Ocho itself, enabling it to expand and reach greater numbers of people.

Local artists who participated included sculptor Ramon Lago, painter Mario Valladares and theater personality Frank Quintana. With the support of the clinic, these artists formed ALAS de la Histórica Pequeña Habana, Inc. (WINGS of Historic Little Havana), an effort to give cultural "wings" to the area. The festival would take place on the last Friday of the month from 14th to 17th Avenues.

According to retired planner Jose Casanova, however, the idea for Viernes Culturales had emerged a decade earlier as part of planned activities for the Latin Quarter; now the timing was finally right. "We had a unique opportunity with the Tower Theater renovated, the new artists coming to live in Little

Robert and Nelson Curras standing outside their mural of Ochun outside CubaOcho Art & Research Center. *Corinna Moebius, photographer.*

Havana and Domino Park and the specialty stores, the cigar stores, music—all the ingredients: I saw it there, and finally it materialized."

Influential business and development leaders like Casanova envisioned the festival as a tool for tourism and economic development, however, while ALAS (and the clinic) wanted to maintain an emphasis on arts and community health, reaching lower-income, local residents. The business contingent won out, which led to the formation of a new nonprofit in charge: Viernes Culturales/Cultural Fridays, Inc., its board of directors almost exclusively composed of early Cuban arrivals like Casanova, Canton and Gort.

The first "talent coordinator"—functioning like the executive director, nonetheless—was Lee Cohen, a local artist born and raised in New York City and of Dominican descent. In the early years of Viernes Culturales, it was well funded through the discretionary funds of county and city commissioners, but with county and city budget cuts, it lost these funds and with them struggled to afford hiring thirteen-piece Latin bands and orchestras.

These early festivals were just one element adding to the neighborhood's *tumbao*, its rhythmic groove; they were a go-with-the-flow affair. Rides were

offered by *la chiva* (the goat), an open-back truck with its radio blaring the latest Latin hits and benches installed for passengers. Revelers packed into *la chiva* all night, boarding at the corner of Calle Ocho and Southwest 16th Avenue (where rumba drummers were playing away) to visit the action at Southwest 12th Avenue and 6th Street.

The streets were crowded with artisans and artists, most of them local. Some of these artist vendors later went on to open their own galleries. One hundred artist vendors participated, representing fourteen different Latin American and Caribbean countries. Although many artists made reference to Elián, often with the image of a forlorn boy in his inner tube, the festival's board of directors did not want Viernes Culturales to become a political stage, as had happened so often to the neighborhood over the past few decades. They created a rule forbidding vendors from exhibiting overtly political work.

On a portable stage set up on Southwest 15th Avenue (and in later years in Domino Plaza), performers entertained people of all ages with live music, folkloric and other kinds of dance, acrobatics, theater and even an occasional magic show. Performers included acts like Havana Soul, "Xochitl de Nicaragua" and the flamenco students of Fina Escayola but also big salsa groups and superstars like Celia Cruz, who sang onstage with the famous Cuban American singer Willy Chirino.

At several of the monthly events, local artist Pedro Damián recruited neighborhood musicians for an impromptu *descarga* (jam session) of *guaguanco* (rumba) in a loaned space next to El Pub on Calle Ocho. He and others called it *La Vena del Gusto* ("whatever's your pleasure"). One night, it featured an overwhelmingly red, altar-like installation created by artist Leandro Soto and dedicated to Changó, Orisha of thunder, lightning, drumming and male charisma; three *batá* drummers performed. "After the Elián thing, it's a very healthy thing," said Soto. "It's like an exorcism."

During Viernes Culturales, more eclectica was taking place at Southwest 6th Street and 12th Avenue, which continues to this day as an arts hub but with different tenants. At the experimental lab6, founders Carlos Suárez de Jesus and Vivian Marthell, along with Artemis Performance Network, presented "Café Neuralgia." "It's that whole *añoranza* (yearning) thing, that Cuban nostalgia thing; we decided to take a dig at that," says Suárez de Jesus. The evening included an exhibit of Little Havana photos by Pedro Portal (lensman for the *Miami Herald*), a digital performance journal by artists Marthell and Suárez de Jesus and a *descarga* by "Freddy and His Crew" (Freddy owned the pizza joint around the corner).

Vignette 15: Dance (2000s)

The 1980s was a pivotal decade for dance in Little Havana, in large part because of new arrivals from the Mariel and Latin America. In 1983, the *Miami Herald* gave a rave review of a dance theater performance at Little Havana's Dade County Auditorium. *Ochun Obbayeye* earned a standing ovation. It was directed and choreographed by Alberto Morgan and starred Juanito Baro as Ochun, Orisha of femininity. Both Morgan and Baro arrived on the Mariel, and both performed with the Conjunto Folklorico Nacional de Cuba, one of the institutions created after the revolution that taught and presented "Afro-Cuban culture" as "folklore." "The culture was there since we were born," said Baro. "The culture is us ourselves," but in the older exile community, she said, "a little bit of rejection comes because of it." Baro taught Afro-Cuban dance classes in Little Havana beginning in 1981. A similar production (*Wemilere*) took place at the Teatro Marti in Little Havana in 1990, directed by Gustavo Cabrera, former director of the Conjunto Nacional.

In the '90s, new energy infused the traditions of Cuban casino and salsa music and dance. Greats like Johnny Pacheco, Marc Anthony,

Marisol Blanco performing dances of Yemaya at the Afro-Cuban cabaret with Los Herederos at Club Ache on Calle Ocho, 2011. *Corinna Moebius, photographer.*

Issac Delgado and Luis Enrique sat in with the house band at Café Nostalgia on Calle Ocho. An unusual figure of the '90s and later was Rogelio Morto, a former political prisoner who danced with his handmade female mannequins on Little Havana sidewalks. New restaurants and clubs owned by non-Cuban Latinos offered spaces to dance to merengue, cumbia and bachata, sometimes performed by live bands from Latin America.

In 2009, the newly opened Manuel Artime Theater in East Little Havana began offering diverse programming in dance. Jumaqi Mamani, a salsero originally from Peru, opened Salsa-Art Studios on Calle Ocho (which also offered classes in merengue), and Carmen Rubio, former ballerina with El Ballet Nacional de España, taught classes in flamenco at a studio in her home close to the Tower Theater.

In a corner that became a hub for arts, Brigid Baker took ownership of 6th Street Dance Studio in 2005, offering classes in contemporary dance and ballet; 6th Street also became a mecca for old-school hip-hop.

Across from the Tower Theater, Irela Roldan opened DAF Studio in 2008, offering the first Zumba® classes in Little Havana (taught by Zumba® founder Alberto "Beto" Perez himself), as well as Afro-Cuban Orisha and rumba dance classes taught by Marisol Blanco. DAF also began hosting a Friday night *Milonga TangOcho* (tango gathering). In 2007 and 2008, Miami Lighthouse for the Blind, in East Little Havana, taught classes in tango to two dozen blind students.

Most recently, Cuban director, choreographer and ballet dancer Pablo Peña opened the Miami Hispanic Cultural Arts Center in East Little Havana and made the historic building home to prestigious arts organizations under his direction. These include the Miami Hispanic Ballet, the Cuban Classical Ballet of Miami and the Cuban Classical Ballet of Miami School, among others.

Spaces like lab6 and PS 742 provided an alternative to what Suárez de Jesus called the "Elián hoo-ha riling the neighborhood" during the Elián González custody battle (mentioned later). For one of the exhibits at lab6, "Monkey Boy and the Parallel Bio-Narrative," the artists put a five-foot latex penis with an eye in its head in front of the storefront window. Protesters walking by the piece would trigger a motion sensor, causing the penis-eye to blink and follow them.

Owner Amanda Vargas cutting a fade at Thumbs Up Barbershop in the 12th and 6th arts hub, 2011. *Corinna Moebius, photographer.*

Local poet Nestor Diaz de Villegas (best known for his "Confesiones del Estrangulador de Flagler Street" [1998]—"Confessions of the Flagler Street Strangler") captured the scene in an essay. "There is no use for nostalgia here," he wrote. "What kind of nostalgia could there be in a place that gathers Nicaraguans, Americans from Massachusetts, Spaniards, Argentineans, Hondurans, Mexicans, all of the fauna of the Cuban *sagüesera*—recent arrivals, *balseros* and Generation ñ?" He was describing what Little Havana—and Miami—had become.

Viernes Culturales coexisted with a creative underground. In a small space close to Calle Ocho, PS742, Artemis Performance Network (run by artist Susan Caraballo) offered its own weekly arts event: Surreal Saturdays. Late Friday nights were reserved for rumba. Acts included a "hip-hop bellydance love battle" and performances by groups like the legendary Miami-based Spam Allstars. The *Miami New Times* recognized PS 742 as "Best Black Box" before it shut down.

Another important pioneer in the scene was Adalberto Delgado, with his 6G space also at 12th and 6th. He earned the name *El Sacerdote de la Rumba* for rumba gatherings he hosted, beginning with "Rumba on 6." "When we had Rumba on 6, lots of Germans, Dutch, French, Spaniards and even Australians—we once had a table of nine—came just to listen to *guaguancó*, *yambú* and *columbia* [forms of rumba], and they knew the distinction of these genres to *salsa* or *merengue*," he said.

Most of these places, however, shut down after just two years of operation. Viernes Culturales changed, too. The shuttles stopped, and there was no more rumba on the street. Fewer artist vendors were participating in Viernes Culturales. Some artist vendors stopped exhibiting on the sidewalk, as they found it difficult to make sales. In East Little Havana, rumors abounded about Viernes Culturales not accepting Central Americans as vendors or that it was expensive to participate. These rumors were untrue, as it cost a mere six dollars a month to participate.

"There are a lot of bad trinkets and knickknacks," said Manny Lopez, owner of Zu Galería Fine Arts, about the changes in the festival's vendors. His gallery sat next to the headquarters of Alpha 66, the anti-Castro paramilitary group; he shared his rear courtyard with the aging guerrillas. "They have been supersupportive," he said about them, mentioning how often they'd drop by with a *colada* (Cuban coffee, to be shared) to chat. "They have even offered to loan me folding chairs for my events." Lopez also held bilingual poetry readings at his gallery and an annual celebration for *La Virgen de la Caridad*.

Artist Agustin Gainza making tile art in his studio on Calle Ocho, 2014. *Corinna Moebius, photographer.*

Zu Galería was one of many new art galleries that opened up, many (but not all) selling the folksy Cuban landscape, cigar and rooster themes preferred by tourists. A Calle Ocho Art District Association formed. Some galleries had studios in the back and sold works distinct from the touristy fare, like Agustin Gainza, Mildrey Guillot and Luis Molina (all of whom still have their spaces). These artists shaped the conversations in local cafés and often visited one another. "This is one of the few pedestrian-friendly areas of the city and a unique place where people can enjoy Latin American culture in all its diversity," said Guillot, who had moved her gallery to the area from Coral Gables.

The oldest gallery in the area, Maxoly, featured a permanent exhibit of Cuban masters but burst into the headlines in 2002, when Vigilia Mambisa, a right-wing Cuban exile group, picketed the space, accusing its César Beltrán exhibit of being "pro-Castro." After gunshots fractured the gallery's windows, the owner (Máximo Sarracino) closed the exhibit—and installed shatterproof glass.

The clothing and souvenir shop next door sold T-shirts and maps promoting "Havami," the fifty-first state of the Union. In 2005, Sarracino

Dr. Paul George leading a walking tour during Viernes Culturales, 2011. *Viernes Culturales/ Cultural Fridays, Inc.*

spearheaded a proposal to Congress calling for Miami-Dade and Monroe Counties to unite with the different provinces of Cuba in order to create this entity. He was successful, however, in getting the strip of Calle Ocho from 12th to 17th recognized as an official arts district by the City of Miami: the Calle Ocho Arts District.

The first "official" souvenir shop had been Little Havana to Go, opened in 2001 by Carole Ann Taylor, who is of African descent and not Latina. Taylor brought Jacqueline Perez to work with her because she, too, had experience in the souvenir business. "There was this great space, sitting right next to Domino Park and with tour buses pulling up—yet people had nothing to buy or look at," Taylor said. They offered free Cuban *cafecitos* to tourists and tempted tour bus drivers with commissions. Then Perez left to open her own souvenir shop next to Maxoly (Old Cuba—The Collection). Taylor became an ardent advocate for Little Havana, serving on the most prominent tourism boards in the city, as well as the boards of Viernes Culturales and other local organizations.

Hundreds of tourists were visiting the neighborhood daily. In April 2007, the Greater Miami Convention and Visitors Bureau invited 250 tour operators to a reception in Little Havana's Domino Park to promote tourism

in Little Havana. They hoped to show the richness of the area so that they would organize their own tours of the neighborhood as well as refer others to do the same. An increasing number of buses began to stop in the neighborhood, most of them in front of Little Havana to Go. Still, tourists were exploring—perhaps not very far, but they were curious.

In the latter part of the decade, Viernes Culturales started attracting more locals and tourists. In 2006, Commissioner Sanchez sponsored a resolution designating the tourist area of Calle Ocho a "Cultural Specialty District," a land-use category that increased the number of liquor licenses in the area to boost entertainment consumption during Cultural Fridays. In a map produced by Viernes Culturales, Calle Ocho between Southwest 12th and 17th Avenues was named the "Cultural Core." The festival included free walking tours of the neighborhood led by Dr. Paul George, who published a book about Little Havana in 2006. That same year, the venerable Teatro Marti in East Little Havana was demolished by the City of Miami. The owner was hit with sixteen counts of fire code violations in 1989; the costs were too much for him to sustain the enterprise.

Domino Plaza, championed by City of Miami planner Jose Casanova (retired), with a mural/floor design by Ronald and Nelson Curras, 2012. *Corinna Moebius, photographer.*

Around this time, a new "Domino Plaza" opened to replace the stretch of 15th Avenue that had separated the Tower Theater from Domino Park. A mosaic of colored concrete, the plaza had a pattern of oversized dominos and a bright and colorful mosaic wall along the side of the Tower Theater, for which the design and the tiles were made by twin brothers and Little

Black box theater Havanafama in East Little Havana, one of the more recent of many notable Hispanic theaters in the neighborhood, 2012. *Corinna Moebius, photographer.*

Havana residents Robert and Nelson Curras. The wall is a monument of Cuban nostalgia, with images of cigars and Cuban coffee cups, mangos and sugar cane and small frames with scenes evoking Cuba and pre-Castro Cuban history: the iconic *malecon* seawall in Havana, a machete and a Cuban flag. The Curras brothers were early exhibitors at Viernes Culturales, with their table right in front of the wall they had designed.

The middle decade saw more recently arrived Cubans asserting their presence in the tourist district, as well as non-Cuban Latinos. For a few years, Viernes Culturales hosted a colorful Carnaval de Barranquilla (Colombia) parade along Calle Ocho. The Latin Quarter Specialty Center finally found its first anchor tenant, CubaOcho Art and Research Center, run by a *balsero*. The elegant space has fine Cuban art on its walls, a courtyard and indoor performances of Latin jazz, *son* and *charanga*; occasionally, groups from Cuba perform. At its bar, one can order the finest rums in the world. During Viernes Culturales, owners Roberto Ramos and his wife, Yeney Farinas Ramos, hire an additional live band to perform on its corner patio. Anyone walking by can listen and dance to these free performances. Not long after opening, CubaOcho became a destination for exiles who had not visited the neighborhood for years, although it was also popular among more recent arrivals.

The burgeoning arts scene, trendy new restaurants and cigar lounges, along with the renovation of the Tower Theater, led to increased investments in the area and the rise of property values. Domino Plaza was built, replacing a part of Southwest 15th Avenue, and Cuban Memorial Boulevard (13th Avenue) was allocated funds for widening Cuban Memorial Park along its median and an expansion all the way to Coral Way (Southwest 22nd Street). The city and the county governments contributed funds for these and other enterprises, hoping to make Little Havana a Hispanic Lincoln Road, which investors desired but many locals dreaded, not wanting the area to lose "its soul."

Area businesses were grateful for the upgrades, and many looked forward to the day when sidewalk café permits would become less expensive so that they could put tables outside their restaurants. This, some said, is what would really open up the area to a truly tourist-friendly environment. It cost a restaurant between $1,500 and $2,000 a month just to have four small tables on the sidewalk. The expense was too much for most businesses to make the proposition worthwhile.

Some of Little Havana's historic buildings were being saved, while many of its bungalows suffered the fate of the bulldozer. Bungalows made the "Most Endangered Historic Sites List" of the Dade Heritage Trust (DHT). The best example of a Belvedere Bungalow in Miami was rescued from

A rescued Belvedere bungalow, now home to Citizens for a Better South Florida, 2011. *Corinna Moebius, photographer.*

demolition by DHT, which used its Preservation Revolving Fund to purchase the building in August 2003. Now it is headquarters for the environmental education nonprofit Citizens for a Better South Florida, founded by Arsenio Milian, a Cuban-born environmental-civil engineer.

A historic landmark was also saved in 2001. The historic old Firestone Building, Florida's largest store back in 1929, was slated for demolition when the property was purchased by Walgreens. The pharmacy chain was convinced by DHT and other community leaders to keep its original structure even as it fulfilled its new community function.

Little Havana activists worried about the arrival of chain stores to the area. In 2006, a string of arsons destroyed a number of popular businesses along Calle Ocho, among them the original and popular hamburger joint El Rey de Las Fritas; La Tradicion Cubana, the largest cigar factory in the area, employing fifty rollers; a Spanish-language bookstore; and a Nicaraguan bakery. Within five years, a huge CVS chain pharmacy would rise up on one of the lots where arson had destroyed local small businesses.

The Calle Ocho Festival entered the new century as a global event: twenty-three blocks long, it was billed as the nation's largest street party, rivaling Los Angeles's Fiesta Broadway in the number of Latino artists and size of

Vignette 16: *Vianderos* and *Fruterias*

Little Havana's roving fruit vendors (*vianderos*) of today do not look much different from those of the 1980s, when Cuban entrepreneurs saw the opportunity to sell in much the same manner as street vendors back on the island. The *vianderos* still use pickup trucks or vans adapted for the display of fruit, vegetables and other products like popular spices or even candles and soap. They have particular routes and times of day when they arrive at various spots in the neighborhood (regular customers know the schedule), and they announce their arrival with tinny jingles broadcast from the vehicle's speakers. Sometimes vehicles park at particular street corners, a colorful sight with big bunches of bananas and net bags of oranges, limes and garlic bulbs dangling from custom-made side shelves.

A *viandero* may specialize in particular fruits like watermelons and sell them piled up while parked along a residential street; for fresh *coco frio*, ask the man standing by the pickup loaded with young chilled coconuts, and with his machete, he'll slice the top off for you.

Little Havana also has its *heladeros* (ice cream trucks) and *afiladores* (knife sharpeners). *Afiladores* stop in front of houses or apartment buildings and sharpen knives, scissors—even machetes.

A *viandero* (fruit seller) in East Little Havana, 1990s. *Hugo Miranda, photographer.*

Far fewer *fruterias*, or outdoor fruit markets, exist than in the past, when places like Amado Fruit Shop and Rancho los Cocos still existed. *Fruterias* usually sell a combination of locally grown and imported fruit, including fruit provided by locals who have a surplus in their backyards (a highly productive mango tree, for instance).

Angel and Guillermina Hernandez still run their fruit market, started decades ago, but are now helped by their two grown sons. The market they bought was one of the early fruit markets in Miami, originally owned by a black Bahamian family, then an Anglo Baptist family and then a Jewish family that made the location famous as the Indian River Fruit Stand. Los Pinareños remains a gathering place for everyone from grizzled Bay of Pigs vets to young professionals; many people consider it a true "heart" of Little Havana.

attendance. In 2009, after the 2008 economic downturn, the Kiwanis Club felt compelled to request a donation of one dollar each from the partygoers to help fund its scholarships and other community programs. It managed to collect only a few thousand dollars, so the practice was discontinued.

A cultural icon of the Cuban community and a Latin musical legend passed in the decade. Celia Cruz, the queen of Cuban music, died in New York on July 24, 2003, of brain cancer, and her passing was mourned on Calle Ocho. Her star on the Walk of Fame was decorated with flowers, flags and candles. All day long for days after her death, mourners visited her star. Tour buses made a special point of stopping nearby and pointing out the emerging shrine. "*Azucar!*" was her trademark exclamation, referring to the sweetness of Cuba and its music. Many wrote these words on various surfaces and left them at the star. One person left a bag of Dixie Crystals sugar on her star. Calle Ocho was in mourning for those few days like never before.

Another significant passing that occurred in the decade was the Orange Bowl. By the end of the decade, and after some contentious politics in city hall, construction started on the new Marlin Stadium in Little Havana. At its groundbreaking ceremony on July 18, 2009, the project held the promise of hundreds of new jobs and a rejuvenation of the northwestern quadrant of Little Havana where a dilapidated Orange Bowl once stood. But protests against the construction of the stadium through the streets of Little Havana started soon after the groundbreaking, first from workers who felt that the

To: Jose Marban *644 — 8643*

El Comisionado Sánchez
les invita

A pasar una noche de cultura y música

En

"Los Viernes Culturales"
Calle Ocho entre la 17 avenida y la 13 avenida

Con

Celia Cruz
y
Willy Chirino

Viernes, 27 de abril, 2001
7:00 de la noche — hasta las 11:00 de la noche

Patrocinado por Bacardi-Martini USA, Inc.

A poster announcing a Celia Cruz and Willy Chirino performance at Viernes Culturales in 2001. *Corinna Moebius Collection.*

hiring practices were discriminatory and then from citizens concerned with costs overruns and corruption.

The shifting demographics of the area continued to manifest themselves in the businesses opening, as well as in the rituals of the neighborhood. Hundreds from all over the Americas and the world joined Cubans,

Fiestas Agostinas (celebrating Santo Domingo de Guzman, patron saint of Managua, Nicaragua) poster affixed to a light pole in East Little Havana, 2013. *Corinna Moebius, photographer.*

Nicaraguans, Hondurans and other Little Havana residents each month in the rhythms of Viernes Culturales, in the symbolic heart of a world desperately trying to hold on to memories and in the process creating a new reality.

Political Culture and the Saga of Elián

The Cuban government did not fall during the 1990s, as anticipated by many Cubans, but Fidel fainted once in public in 2001 and stumbled to his knees after a speech in October 2004. That was almost as good, and it kept pundits active for many weeks. As Castro's health deteriorated and he handed the reins of power over to his brother on July 31, 2006, death watches would spring up, and plans were made for rallies and marches each time Fidel was not sighted during some significant event on the island. In 2007, the City of Miami began to plan an Orange Bowl event to follow Castro's death. Talk of themed T-shirts and musicians prompted criticism that the city was hosting a taxpayer-funded "Death Party." By the time Fidel officially retired and announced that he would not seek reelection in February 2008, he was old news.

Overall, the first decade of the new century saw a decrease in the reported number of protests and demonstrations designed to precipitate the fall of the Cuban government. But Miami in general and Little Havana specifically continued to be identified as the capital of Cuban exiles. When the exile voice needed expressing or when the media or pundits or other interested parties wanted to hear what exiles had to say, the microphones were set up in Little Havana.

Protest against the Cuban government continued, not at the rate of those in the 1990s but with as much intensity and urgency. An estimated forty thousand people rallied on March 20, 2003—led by congressional representatives Lincoln Diaz-Balart, his brother Mario Diaz-Balart and Ileana Ros-Lehtinen—in opposition to the Nation and Emigration conference being held in Cuba in April of that year, in which several Cuban Americans from Miami would participate. The march had a patriotic tone associated with U.S. foreign policy in general, as the marchers expressed support for the Iraq war, with the inevitable comparison between Fidel Castro and Saddam Hussein.

The decade also saw the rise of the first Cuban American Democrat to be elected to Congress. Little Havana was one of Joe Garcia's first podiums used to express his views on how Republicans had been handling Cuban policy. Addressing a Democratic Party rally on September 21, 2004, in Little Havana, Garcia denounced President Bush. Although it took him several tries, Representative Garcia, as of this writing, is the freshman representative of Florida's 26 District, elected in 2012.

During the decade of 2000, Cuban Miami began to openly question the effectiveness of U.S./Cuba policy. The arrival of hundreds of thousands of

Vignette 17: The Orange Bowl

"We had the Orange Bowl on the corner," says a Cuban American resident who grew up in Little Havana. "I remember sitting outside and listening in; when the crowd cheered, I knew we scored, and when I heard the collective moan, I knew someone scored against us." The Orange Bowl stadium was demolished in 2008 to make way for Marlins Park. Mother Nery of San Lazaro Church recalled seeing dozens of families sitting in their cars and weeping after the final game at the Orange Bowl (fans liked to park in the church's large lot).

The Orange Bowl was best known for sports games but also for the huge events—mentioned throughout this book—that brought communities together. On July 20, 1986, it hosted a record-breaking citizenship ceremony, becoming the "Liberty Bowl" for more than

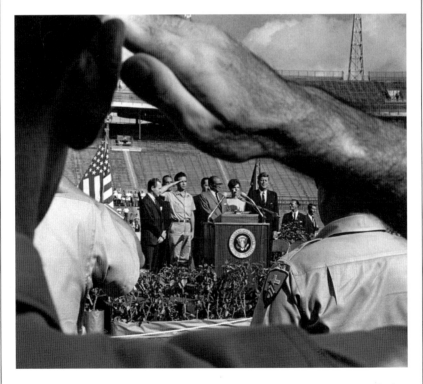

Brigade 2506 veterans salute President and Mrs. Kennedy, December 1962. *Charles Trainor, photographer. Miami News Collection, HistoryMiami, 1989-011-21744.*

twelve thousand new citizens from sixty-eight countries. Retiring Supreme Court chief justice Warren Burger inducted the new citizens via a satellite link from Ellis Island. The event also celebrated the 100th anniversary of the Statue of Liberty.

Wearing a *guayabera* shirt, President Ronald Reagan spoke at the Orange Bowl in 1990, speaking before a predominantly Cuban audience of about ten thousand. In attendance was future Florida governor Jeb Bush. Reagan's anti-Castro speech was broadcast live to Cuba via the U.S.-funded Radio Marti, which was then in its fifth year.

The University of Miami trustees decided to move the Hurricanes' games to Dolphin Stadium in 2007, thus sealing its fate: the stadium would not be renovated. It had hosted five Super Bowls, presidential speeches, concerts, boxing matches, Mariel refugees and Olympic soccer games. Here, the Hurricanes had won three national championship games and from 1985 to 1994 enjoyed a NCAA-record fifty-eight-home-game winning streak.

Little Havana residents were upset about the demolition of the Orange Bowl, even if they were hopeful about the Marlins Park stadium to replace it. In homage to the park, graffiti artist Atomik made his trademark: an orange with a smiling face. Atomik, who is of Puerto Rican descent, grew up watching the games with "pops." "I added a tattoo tear next to his eye, and in the tattoo world, that signifies that you've killed someone," he said. "I put it to signify that they had destroyed the Orange Bowl and killed it, essentially." His orange trademark can be found on various walls throughout Little Havana, including the Good Wall on the southeast corner of Southwest 10th Avenue and Calle Ocho.

Cubans from the island since the 1995 immigration agreement changed the demographic and ideological landscape. Newly arriving Cubans were more likely than the old guard to want to return to the island to visit friends and relatives. The U.S. policy initiated by Bush in 2003 limited the visits of Cuban Americans to the island to once every three years and only to visit close relatives. This policy was not supported by many Cubans in Little Havana and was opposed by a large majority of the new arrivals. In previous decades, the debate would have been most visible on Calle Ocho. In 2007, however,

it became an actual debate inside Little Havana's Tower Theater attended by hundreds of residents. On stage were Representative Jeff Flake from Arizona, Professor Lisandro Perez from Florida International University, Paul Crespo and Esteban Bovo, the Hialeah City Council president. Flake and Perez argued in favor of changing the law to allow more frequent visits by Cuban Americans. Crespo and Bovo argued in favor of keeping all trade and travel restrictions as they existed at the time. The audience response was impassioned, with frequent boos and applause, but the mere fact that the event was held was trumpeted as a change in community attitudes. On the ground, this kind of open debate had a mellowing effect on the community as a whole.

The ideology of the exile community continued to be imprinted in its geography. On September 5, 2009, for example, a sculpture honoring the participants of the Pedro Pan operation, which brought over fourteen thousand unaccompanied minors to the United States from Cuba from December 1960 to October 1962 under the auspices of the Miami Archdiocese of the Catholic Church, was unveiled on the corner of Southwest 13th Street and 20th Avenue in Little Havana.

The most dramatic event of the decade kept the eyes of the nation focused on Little Havana for five months between November 1999 and April 2000. The "Saga of Elián," as the *Miami Herald* declared it in its daily coverage and over two thousand articles, highlighted the desires of the Cuban American community to present a united front against the Cuban government, as well as the contradictory nature of the idea of family reunification within the exile community.

On Thanksgiving Day 1999, a six-year-old boy was found floating on an inner tube three miles off the Florida coast. The U.S. Coast Guard spotted Elián González and the two other survivors of a vessel carrying fourteen passengers from Cuba and immediately transferred Elián to Joe DiMaggio Children's Hospital. The two other survivors were rescued after they swam to Key Biscayne, a few miles from downtown Miami.

The story of Elián started similarly to that of many others who have risked their lives crossing the Florida Straits and eventually settled in Little Havana. The fact that he was six years old and that his mother had died in the crossing kept the public eye open and tearful as his story was related. Much would be made about his mother's intent. The critical question—should the boy remain in the United States or rejoin his father in Cuba—was often couched in the emotions surrounding a mother's sacrifice for her child. If he was returned, her life would have been given in vain, many in and outside

A crowd outside the home of Elián González, April 15, 2000. *Gustavo Roca, photographer. Courtesy of the Cuban Heritage Collection, University of Miami Libraries. Cuban Photograph Collection.*

the Cuban American community felt. But try as they might, those wishing Elián to stay in the United States could not erase one incontrovertible fact: Elián had a father, and the father wanted his son back. Ultimately, on Easter Saturday six months later, the father got his wish, but not before his son had played the role of protagonist in one of the most defining moments of the Cuban American experience in Little Havana and in the United States.

Within two days of his discovery, Elián was found to have relatives in Little Havana. Lázaro González was his great-uncle who had arrived in the United States over a decade earlier. On November 26, Lázaro took Elián "home" to Little Havana.

In Cuba, Elián's father declared two days after the boy was found that he wanted his son back. The INS made two visits to the island to interview Juan Miguel. After the visits, the INS agreed that Juan Miguel was sincere in his wishes to have his boy returned. On January 6, 2000, then attorney general Janet Reno issued the decision to return the boy to his father in Cuba. Ultimately, the issue was resolved by the use of force. The INS forcibly entered the Little Havana home of the Miami relatives before dawn on April 22. Fortunately, the small number of observers on the scene

presented only token resistance to the well-armed strike force. Pictures of the raid circumnavigated the globe via Internet, television and newspapers. Elián was reunited with his father a few hours later. These events have left an imprint on Little Havana, on community relations throughout the Greater Miami area and on the image of Cubans in the United States.

Little Havana Today

2010–2015

The last five years have seen an explosion of change in Little Havana, with an increase in civic engagement, cultural institutions and hybrid spaces but also tensions among those who want to ride the wave of its new and creative energy, renters fearful of being displaced from the neighborhood and those who want to transform Little Havana into West Brickell, an expansion of downtown. What is distinct about this half decade is a changing of the guard: many of the leaders who controlled the tourist area of Calle Ocho have moved on, and the new majority is younger, more ethnically diverse and more female. Another tension exists between those who want to promote tourism and those who worry about a neighborhood that prioritizes tourists over its own residents. The stark contrasts between East Little Havana (and other parts of Little Havana) and the Calle Ocho core continue.

At its peak in 1980, the Cuban community composed 85 percent of the Hispanics in Little Havana. Today, that number is under 40 percent. There are 1.9 million Cubans in the United States. Nearly 900,000 live in Miami-Dade County, and of the ones living in Miami, 35 percent have arrived since 1995. These new arrivals are the ones who are populating Little Havana as earlier arrivals move out to the suburbs if they can (or want to).

The community has changed considerably since the 1980s. The changes are particularly obvious in the area between the Miami River, Marlins Park and north of Southwest 8th Street. According to the 2012 American

The *Good Wall* mural on Calle Ocho at 10th Avenue, on the side of a Goodwill Superstore, 2014. *Corinna Moebius, photographer.*

Community Survey, Central Americans account for approximately one out of four residents in Little Havana. The new arrivals are from Honduras, one of the poorest countries in the hemisphere, and Guatemala and El Salvador, two countries undergoing profound economic and political upheaval. Dominicans, Mexicans and Peruvians are also in the mix. All are mingling with many of the established resident Nicaraguans who began their settlement of the area in the 1980s and the more recent Cuban arrivals. The new arrivals are being pulled by the same conditions that attracted the Cubans over fifty years ago: cheaper rents, the availability of multi-family homes and proximity to jobs in higher-income areas. The residents of Little Havana tend to find work in the service sectors of the higher-income areas like Brickell, Miami Beach and Coral Gables, as well as in trades like construction, car repair and landscaping. Some operate businesses from their homes, making traditional foods, mending clothes or holding yard sales.

The Miami Marlins (renamed from Florida Marlins in honor of their new home) played their home opener in 2012 against the St. Louis Cardinals at their $639 million publicly financed Little Havana stadium built on the footprint of the old Orange Bowl. The park has been a mixed blessing

VIGNETTE 18: *LA PURISIMA* AND *LA GRITERIA*

Since the early 1980s, Nicaraguans in Miami have publicly celebrated a custom they did not want to leave behind in their homeland—one that involved shouting in the streets! As part of the patronal festival for *La Virgen de la Asuncion* (Virgin Mary), patroness of Nicaragua, they held (and still hold) *purisimas*: private parties during which guests recite the rosary and sing *villancicos* for the virgin. The hosts give them *el pequete* afterward: small gifts and customary home-cooked treats. The season for *purisima* runs from November 26 through January, but one of its rituals, the public *Griteria*, is held on December 7 (the last day of what is called the *novenario*).

In the evening of *La Griteria*, people of all ages gather in front of storefront altars on which are placed images of *La Virgen de la Asuncion*. Altars are often decorated with colored lights, bouquets of flowers and sometimes handpainted backdrops. Participants roam in groups from altar to altar, singing *villancicos* at each one; some make noise with

A crowd outside an East Little Havana business (West Flagler Street) during *La Griteria* celebrations, 2011. *Corinna Moebius, photographer.*

145

whistles, tambourines, maracas and rachet-like rattles. Others may wave incense in the air. Key to the ritual is the call-and-response exchange: "*Quien causa tanta alegria?*" "*La concepción de Maria!*" (Who is the cause of so much happiness? The conception of Maria!). Hosts of the altars hand out toys and sweets to those who stop by and sing.

In East Little Havana, celebrations cluster along West Flagler Street and Southwest 1ˢᵗ Street. Locals visit altars in front of small stores and at the Nicaraguan Consulate and San Juan Bosco Catholic Church. In 1991, at longtime Nicaraguan eatery Yambo, owner Armando Perez installed a glass-enclosed statue of *La Virgen de la Asuncion* in time for *La Griteria*.

At San Juan Bosco, the monsignor and attendants bring out the image of the Virgin Mary along an upper walkway outside where it faces the crowd of hundreds below in the large parking lot. Fireworks crackle in the air, and a pickup truck arrives with barrels of *chicha de maiz* (a corn drink with ancient origins), which is handed out for free. Cars parked on the edge of the lot have elaborately designed makeshift altars constructed on top of their trunks or hoods; their owners also give out gifts to those who sing.

Some businesses participating in *La Griteria* host the satirical performances of *La Gigantona* and *El Enano*, accompanied by the improvised and witty verses of *El Coplero* and the drumming of the *Tambilero*.

In 2011, local businesses waited months to get their permits in order to install altars for *La Griteria*, but to no avail. During *La Griteria*, they were told by police to shut down their altars. Business leaders complained to the East Little Havana NET office, pointing out that a march had taken place along Calle Ocho without permission from the city and nonetheless with a police escort. Since 2011, police have not bothered businesses choosing to set up altars, but fewer businesses have chosen to continue celebrating the tradition.

to the community. Parking issues emerged almost immediately as the city eliminated street parking along many of the streets around the park to accommodate the game-day traffic. Even though some of the parking has been reopened during non-event days, the hardship imposed on many residents caused many to move out of the area. For local hip-hop artist E.R.,

Marlins Park inspired the cover image for his freestyle "My City," an ode to his stomping grounds in Little Havana. He used a photo of the intersection at Northwest 17th Avenue, with the glimmering new stadium positioned in front of small, ragged homes. Some buildings are boarded up around the stadium, but there is a street life full of kids and mothers pushing strollers alongside the aged Cuban men selling fruits from their open vans.

There was hope that the advent of the new stadium would improve the neighborhood and increase home prices, but little impact has been felt on home values. Property data reported in 2013, as the Marlins began a third season at the ballpark, show that the state-of-the-art stadium has had a minimal impact on the residential real estate market. An average condo in 2013 sold for about $83,700. In 2012, the same type of unit sold for an average of $77,400. This type of anemic growth contrasts sharply with the skyrocketing real estate market in South Florida in recent years.

Trademark events—the Calle Ocho Festival, Three Kings Parade and Viernes Culturales—continue to grow, but new and grass-roots events are having the greatest impact on the neighborhood's local identity, not just through direct participation but also through the power of social media. These include the Little Havana Art Walk and the Flagler Nights Festival. Although it took place for only a few months, Flagler Nights brought together young Miami activists (from Emerge Miami) with local community organizers and working-class immigrants, who met at a shared workspace/incubator that had opened in East Little Havana: Barrio Workshop. The space for Barrio is owned by developer Jose Fernandez, who has long been an active proponent of development in Little Havana. Some of the activists remain involved in the neighborhood, assisting in efforts to improve pedestrian safety, for instance. The festival featured everything from food sold by family-owned East Little Havana businesses to performances by young Latino alt-rockers to tire swings put up under the Flagler bridge. For some of the organizers, the festival was intended to attract visitors from outside the neighborhood; most of the locals wanted a festival for neighbors to enjoy.

When Brickell Motors cut down several street trees along Calle Ocho, the photos appeared on Twitter, along with a public scolding by a resident. East Little Havana resident Sharif Salem earned national attention for his Instagram page, "Sofas of Little Havana" (documenting the use of Little Havana as illegal dumping grounds). Facebook groups launched: Little Havana/La Pequeña Habana News & Events, Friends of Little Havana and Growing Up in Little Havana. And Hugo Miranda uses Instagram to

exhibit his compelling photos of the East Little Havana *barrio* where he has lived for years with his wife, Sonia.

The Twittersphere (and national media) was abuzz when one of the neighborhood's best-known rooster sculptures disappeared: the "Cuban-American rooster" at the corner of Southwest 16th Avenue and Calle Ocho, in the heart of Calle Ocho's tourism district. Rumors abounded in response to the crime. Many locals assumed it was an act committed by gang members. Then, news leaked out that it had been stolen by a college fraternity as a prank. A fraternity brother confessed to the crime and negotiated a deal with Canton: the fraternity would pay for repairing and reinstalling the rooster and donate community service hours for Viernes Culturales.

Cuban American entrepreneur Bill Fuller, through his company, Barlington Group, is one of the most influential and visible developers in the area. Fuller and his business partners have developed numerous properties in the neighborhood, all of which Fuller carefully "curates" in hopes that they will benefit the area, whether by providing employment for low-income residents or by adding to its arts movement.

Each of these properties, most purchased after 2010, has earned significant attention. One of them, across from the Tower Theater, houses a popular ice cream shop, Azucar, the Little Havana Cigar Factory, DAF Studio (dance) and a jazz/Miami boheme/Latin bar/nightclub reopened under the original name from its heydays as a jazz club in the '30s through the '50s: Ball & Chain. Futurama 1637, where the Barlington Group office is located, houses more than a dozen studio galleries. Barlington owns the L-shaped building on the corner of Southwest 12th Avenue and 6th Street, the hub that has long served as a center for alternative arts and is now home to 6th Street Dance Studio, art studio galleries (including those of "Miami's Mosaic Man" Carlos Alves, urban artist Danny "Krave" Fila and longtime curatorial innovator Adalberto Delgado), a bakery and Cuban sandwich shop, a barbershop and ArtSpoken Performing Arts Center, a tiny black box theater that presents avant-garde and lesser-known works. Barlington also bought the historic Tower Hotel just behind CubaOcho and, most recently, the building housing the longtime community organization Vecinos en Acción, for which Fuller plans to offer an outdoor food market for low-income residents. Fuller, who is Cuban American, and his partners are Little Havana's Generation ñ developers.

The Little Havana Merchant Alliance (LHMA) was founded in 2011 by Bill Fuller and Corinna Moebius to fuel local civic engagement and collaboration among area organizations and businesses and to promote

The ribbon cutting for a new Vecinos en Acción clinic (Laura Gonzalez second from right, Fernando Gonzalez on right), 2012. *Corinna Moebius, photographer.*

an area still stigmatized by the reputation it earned in the '80s. LHMA complemented the work of the Calle Ocho Chamber of Commerce. In 2012, more than one hundred people attended a Little Havana Open House organized by LHMA, during which local organizations shared their missions and recent projects. Local organizations that have benefited from new partnerships include ConnectFamilias, which in 2013 was awarded $3,750,000 for a six-year Healthy Community Partnerships Initiative based in Little Havana.

Pedestrian safety remains a critical issue in the neighborhood. Between 2005 and 2011, there were 382 pedestrian crashes in Little Havana and twenty-eight fatalities. In an attempt to make Little Havana more pedestrian friendly for tourists and residents, grants from the Pfizer Foundation and Grantmakers in Action allowed Urban Health Partnerships to conduct research to identify the biggest obstacles to increasing safety for pedestrians. The Miami-Dade Safe Routes to Age in Place project was a partnership among the Health Foundations of South Florida, Urban Health Partnerships and the Cuban American National Council to make Little

Vignette 19: Murals

Some of Little Havana's earliest murals—like the whimsical scene outside Casablanca cafeteria and a mural of domino players in Domino Park—have been painted over and lost forever. In 1977, Cuban-born artists Gabriel Sorzano and Ricardo Pedreguera painted a huge, twenty-four- by thirty-foot mural of Cuba's patron saint on the outer wall of the Tower Theater. The colorful, mandala-inspired design was based on Pedreguera's original watercolor painting. It was painted over during the theater's renovations.

Summit of the Americas is one of the earliest of the still-existing murals, completed in 1994 by the late Oscar Thomas, who painted it in Domino Park. Oscar Thomas sought to "create a positive vision of Afro-American role models in our society and history." His image of Latin American presidents and prime ministers reveals more than a few of African descent.

Cuban American artist Xavier Cortada has a long legacy in Little Havana. In 2001, he finished his *Riverside Garden and Manatee* mural. In a small park beneath the Flagler Bridge, this mural of a manatee honors the endangered sea mammal. Cortada says it led to a lot of his later environmentally oriented work, for which he is now known internationally.

Other early murals were constructed in the Little Havana home of Ronald and Nelson Curras, identical twin Cuban-born ceramicists.

Original mural by Luis Manuel Cuadra Peralta (Archie Nica) and Chepe Nicoya, 2007. *Photo by Infrogmation, Creative Commons Attribution 2.0 Generic (self | GFDL | cc-by-2.5).*

Their home's interior is like a museum, with brightly colored mosaic designs covering floors and walls. The Curras brothers designed the mosaic floor and wall of Domino Plaza, as well as mosaics on benches in Cuban Memorial Park, outer walls of CubaOcho Art & Research Center and a McDonald's.

Across from that McDonald's, Little Havana resident Luis Manuel Cuadra Peralta (better known as Archie Nica, a name his schoolmates gave him in Nicaragua) and Chepe Nicoya painted a mural on Southwest 14th Avenue, in 2007, commissioned by a tiny Nicaraguan *fritanga* on the corner. It depicted a Nicaraguan village with women preparing tortillas against a backdrop of homes, mountain and sky. In big letters, "¡VIVA NUESTRA RAZA!" (Long live our people!) was emblazoned below. A hodgepodge of historical figures—from Abraham Lincoln to Celia Cruz to Selena—appeared on both sides of the scene. After the *fritanga* shut down, a new restaurant/club called Art of Freedom opened up with Cuban management. It had Archie Nica repaint the mural to include more Cuban figures and call it *Arte de Las Americas*. He maintained his "VIVA" statement but in smaller letters; a new scene depicts workers plowing the fields and picking tomatoes. Archie Nica's murals can be found on walls throughout the neighborhood.

Local developer Bill Fuller has actively promoted local mural and graffiti art, as has developer Jose Fernandez. After Fuller's company (Barlington Group) bought a building at 15th and Calle Ocho, he asked well-known Miami urban artist Danny "Krave" Fila to paint a mural on an outside wall: *Damas en Blanco*. This 2010 mural depicts the Ladies in White, an opposition movement in Cuba consisting of the wives and female relatives of jailed dissidents. Nostalgia with a twist.

Barlington Group also owns the property housing a Goodwill Superstore on Calle Ocho, and in 2012, the group wanted graffiti/ urban art on its outer walls. Artist Diana Contreras agreed to curate what she coined *The Good Wall*. The mural is divided into smaller squares, each featuring signature artwork by Miami urban artists. Famous French artists "Invader" and "Blek the Rat" also "tagged" the building with their highly prized art. Contreras, who is of Peruvian descent, completed her own mural on a wall next to Fuller's Futurama 1637 building.

In 2008, Cuban artist and author Baltasar Santiago Martin founded Fundacion Apogeo, through which he began working with CubaOcho to install a number of murals on the walls of the Latin Quarter Specialty Center where it is based. Many of the murals were completed by award-winning Cuban artist Aristides Pumariega, widely known in the Cuban community as Aristide. His works highlight old-time musical legends of Cuban descent and even such surprises as Cuban American artist Pitbull and The Beatles. Apogeo also commissioned murals by other artists for its outdoor space.

When developer Jose Fernandez asked Miami artist Corinne Stevie to do a mural on the wall of his East Little Havana Barrio Workshop property in 2012, she depicted Ochun, "owner of rivers," wearing glasses, transforming the Orisha with her signature "Afro-Punk" style.

Additional murals appear regularly on the walls of Little Havana, some of which stay and some of which are painted over.

Havana more pedestrian friendly. Half of the fatalities involved older adults. The partnership made its recommendations known to the community in a forum held in March 2013. An action plan was forwarded to city planners suggesting, among other things, extending the length of some stoplights, removing tripping hazards and creating defined bicycle paths. Changes to Calle Ocho, a state road, are the responsibility of the Florida Department of Transportation, which began organizing public meetings in 2014 as part of a long-term planning effort to make Southwest 8th and 7th Streets more pedestrian friendly.

In 2014, nearly all of the "old guard" of the organization Viernes Culturales resigned from the board; it was a sign of change. Old guard businesses shut down, too, like Ayesteran Restaurant, which closed its doors in May 2013. Rodolfo and Orestes Lleonart first opened Ayestaran Supermarket in 1966 and soon after opened the restaurant that served celebrities and politicians for nearly fifty years. In 1995, the restaurant enjoyed a moment in the spotlight as one of the sites for the Antonio Banderas and Mia Farrow film *Miami Rhapsody*. The restaurant was closed for several hours at night for the shooting of the film, in which Orestes was an extra.

The olfactory and culinary profile of the neighborhood continues to be de-Cubanized as well. Nicaraguan *fritangas*, or cafeterias, like the popular

Pinolandia, are commonplace, selling *queso frito* and *nacatamales*—and some of them are on Calle Ocho, too. The area is also host to highly rated restaurants offering the cuisine of Honduras, El Salvador, Guatemala, Mexico, Spain, Bolivia, Argentina, Uruguay, Peru and Colombia.

POLITICAL CULTURE

The symbiotic relationship between Little Havana and Grande Habana has persisted for over fifty years. On March 25, 2010, thousands of Cubans and fellow travelers marched along Calle Ocho in support of Las Damas en Blanco, the Ladies in White, a group of peaceful dissidents composed of wives and mothers of Cuban political prisoners who oppose the Cuban government. Several hunger strikers at Cuban Memorial Plaza on August 1, 2013, protested the treatment of fleeing Cubans intercepted by Bahamian authorities. Solidarity was expressed by a sparse crowd, but the press interest in the incident catapulted the neighborhood event into the broader discourse about Cuba/U.S. relations.

More ritualistic public events draw thousands into the streets yearly for commemorative dates. Every May 20, Cuban independence from Spain is a reason for the neighborhood to celebrate. Jose Marti's birthday on January 28 continues to draw a crowd, as does Antonio Maceo's on June 14. And with each new decade in exile, new commemorations are added to the yearly schedule of remembrances. The day that Elián was removed from the neighborhood (April 22) still draws attention, although the tenth anniversary of his return in 2010 was the last time that he was bestowed a full-fledged remembrance.

Every April 15 protest and remembrance brings an aging crowd to the Cuban Memorial Monument as anniversaries of the Bay of Pigs invasion are celebrated at the monument dedicated to the Brigade 2506. On February 24, Cubans often stop traffic along Calle Ocho to mark the appropriate anniversary of the four Brothers to the Rescue fliers and, inevitably, to call for the release of political prisoners in Cuba along with regime change.

Fatigue and disillusionment are setting in among the old exiles, though, and those who are tired of letting these exiles represent the "entire community" are becoming more vocal. When, on February 24, 2013, Raul announced that he would step down from power and into retirement in 2018, thus ending sixty years of Castro rule, there were no loud pronouncements on

A march along Calle Ocho commemorating Brothers to the Rescue pilots, 2011. *Corinna Moebius, photographer.*

Spanish-language radio or clanging of pots in the streets. Little Havana was quiet, as if exhausted from expecting changes for so long with so little reward or disinterested in an event that seemed foreign to many of the new residents of the neighborhood.

Civic groups that are not focused on Cuban issues have also discovered that to reach the Cuban audience, they have to engage the Cuban exile gatekeepers in Little Havana. When gay activists, on April 29, 2010, wanted to draw attention to the multi-ethnic nature of their struggle against the "Don't Ask, Don't Tell" policy and in support of President Obama's anti-discriminatory stance on gays in the military, they headed to Versailles Restaurant to ask for repeal of the policy. Similarly, when immigration issues need attention, Little Havana is the stage that the audience expects to view. On April 25, 2013, a caravan from Little Havana to Doral, the home of the largest Venezuelan community in Florida, pushed for a speedy enactment of immigration reform to legalize the more than eleven million undocumented immigrants in the United States.

The Occupy Movement mobilized in Little Havana as well. Protesting big corporations, income inequality and unemployment, a broad swath of mostly young South Floridians wound through blocked-off streets from Little Havana's Jose Marti Park to Brickell on November 16, 2011, showing solidarity with the nationwide Occupy Movement.

Politicians still make the pilgrimage to Little Havana when they want to "talk Cuban" to Cubans. Rick Scott made the stop in 2010, and Paul Ryan spoke tough on Cuba in his 2012 campaign rally in Little Havana. Charlie Crist made his obligatory stop in 2014 as a Democratic gubernatorial candidate bashing the policies of Republican Rick Scott. The 2014 FIU Cuba Poll showed that 51 percent of Cuban American registered voters still are unwilling to lift the fifty-four-year-old embargo on the island, even though it has done little to motivate the regime change it was designed to encourage. Younger and newly arrived Cuban Americans are more likely to desire a new policy toward Cuba, but they're also less politically involved and more apathetic. That is why the old exile voice seems to dominate even as generational shifts occur.

AN EVOLUTION OF MUSIC IN LITTLE HAVANA

The changes in music in Little Havana over the last five decades reveal how the neighborhood itself has changed. In the 1960s, recent Cuban émigrés had to rent banquet halls like the Polish American Club on 22nd Avenue or hold parties in private homes in order to hear their favorite music live in Little Havana. Later, they created their own local spaces, like Baturo and Centro Vasco.

After 1980, a greater variety of nightclubs began to open up, like La Tranquera, one of the best established Colombian clubs, with international

Amaury Gutierrez performs at Hoy Como Ayer, 2007. *Courtesy of Amaury Gutierrez.*

performers as well as its own live bands. Brothers Hector and Jorge Alarcon, who also owned the Chibcha in New York City, bought the club in order to appeal to Miami's Latin American audience. The club was always full, mostly with Colombians, dancing to music like cumbia, tango and salsa. Cuban exiles trying to capture memories of a pre-Castro Havana nightlife went to Copacabana, a nightclub opened by Versailles owner Felipe Valls.

Perhaps the most pivotal space for music in Little Havana was Café Nostalgia, which opened on May 25, 1995, at 2212 Southwest 8th Street. Music took precedence over political fingerpointing in this space, even though owner Jose "Pepe" Horta, who'd arrived in 1994, was accused by some Cuban exiles of running a communist club. The club was a safe haven for young Cuban artists, actors and filmmakers but was eyed warily by factions of the exile community, who made threatening phone calls and insulted Horta on radio shows. Cuban music of all kinds was heard here: a cha-cha-cha, *son* or ballad would transform into a wild *descarga* (jam session) incorporating new styles from Cuba like *timba* (a fusion of Cuban *son* with elements of funk, hip-hop, salsa and jazz). The house band, Grupo Café Nostalgia, included young virtuosos such as bassist Omar Hernandez, former bassist with pioneering jazz groups AfroCuba and Cuarto Espacio, and others who would soon become prominent figures in Miami's

music scene, such as singer Luis Bofill and keyboardist Michelle Fragoso. All had left Cuba in recent years. Locals loved the music, and so did celebrities and music stars like Matt Dillon, Andy Garcia and Ruben Blades. They knew that Little Havana had more than just politics and cigar shops. Famous musicians sat in with the band, and like the liminality expressed by Little Havana, it was something "betwixt and between."

Just before Café Nostalgia had opened, Centro Vasco had also been expanding its musical repertoire, beginning with performances by recent Cuban arrival Albita Rodriguez. The popularity of Albita had inspired the owners to host their own *descarga* on Thursday nights. "Albita's significance was sparking something like a rediscovery of Cuban music in Miami," said Nat Chediak, who sponsored the *descargas*. Albita later earned two Grammy awards.

Despite its success, Horta decided to move Café Nostalgia to glitzy Miami Beach in 1997. Eduardo Lama preserved Café Nostalgia's old space and called it Hoy Como Ayer (Today Like Yesterday), the name of a famous song by Beny Moré. He hired many of the same players, and in 2002, he took the advice of Generation ñ promoters Ralph de la Portilla, Erik Fabregat and Jennifer Smith de Castroverde, who announced that they were outlawing nostalgia and starting up ¡*Fuácata*!, which loosely translated means "Wham!" or "Booya!" The Thursday night event showcased the Miami Latin fusion band Spam Allstars, a pioneer of a genre that would become known as Miami Boheme. Said de la Portilla, "We'd like the torch passed over to us in this wonderful historic district in Miami that basically has been associated with hard-line Cuban exiles." They wanted to attract to Little Havana "a twenty-five- to thirty-seven-year-old demographic that is usually alienated from any Little Havana scene," said de la Portilla.

Their British-Venezuelan friend Andrew Yeomanson (DJ LeSpam), a collector of vintage Cuban and Puerto Rican vinyl, spun his tropi-funky-electronica grooves on turntables alongside the All-Stars, musicians (most of them recently arrived from Cuba) who mixed Afro-Cuban percussion with horns, flute and voice. They called the sound "electronic *descarga*." Today, Spam Allstars performs nationally, with more than two hundred shows a year.

A year later, another group began to perform during certain ¡*Fuácata*! weeks: PALO! PALO! was founded by Cubanized Jewish American composer, arranger and keyboardist Steve Roitstein, who co-produced, arranged and performed on records for Willy Chirino and arranged and played on records by Celia Cruz, Tito Puente, Cheo Feliciano and Oscar d' Leon. Roitstein calls PALO!'s sound "Afro-Cuban funk." The group's band members became well-known figures in Miami's scene: singer Leslie Cartaya, Philbert Armenteros (also well known for his drumming

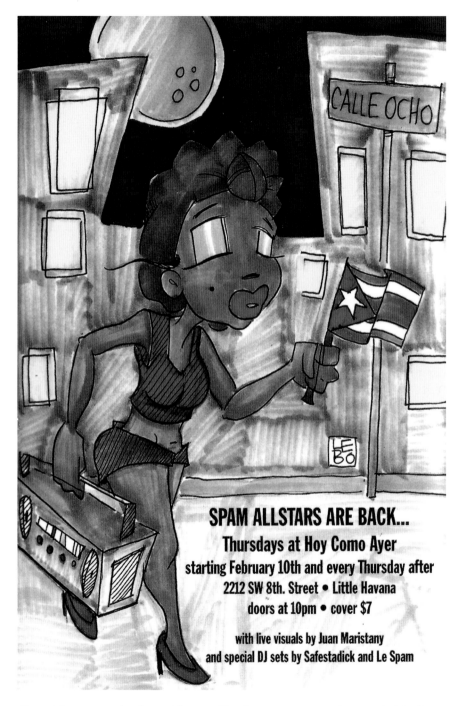

¡Fuacata! flyer announcing Spam Allstars at Hoy Como Ayer, 1994. *Flyer design by Lebo. Spam All-Stars. Eleven:11 Entertainment, Inc./Spam Allstars.*

and singing in the Lukumi/Santeria community), saxman Ed Calle and drummer Raymer Olalde.

Roitstein, an aficionado of Little Havana who is often seen smoking cigars at the Little Havana Cigar Factory, was an early adopter of social media and in 2010 organized the first Tweetup in Little Havana at El Exquisito Restaurant on Calle Ocho, next to the Tower Theater. PALO! grew in fame at Hoy Como Ayer and began performing at other area venues, including PAX (Performing Arts Exchange), a bohemian space with an underground feel run by music lover Roxanne Scalia. It was located under the I-95 overpass and next to the 1980 location of Tent City. Scalia promoted top local and international acts: father of hip-hop Afrika Bambaataa, France's Sergent Garcia, Chilean rapper Ana Tijoux and local artists like Locos por Juana, PALO!, Suenalo, Elastic Bond and Los Herederos. After three years in business, however, the club closed at the end of 2013, the same year the *Miami Times* named it Best Latin Club. In 2014, a PBS documentary about the "Miami Boheme" Latin fusion sound that began in places like Café Nostalgia/Hoy Como Ayer was nominated for an Emmy award.

In the early part of the decade, more music venues opened catering to "mainland" Latin Americans and featuring both DJs and live bands from countries like Nicaragua, Honduras, Mexico and Guatemala. Chatos Nightclub, Club Caribe and El Palenque Nightclub were among them. Above the popular Mexican restaurant Taqueria El Mexicano, the owner is known to pass around tequila shots to customers, many of whom arrive in cowboy hats ready to dance to *norteño*, *banda* and *duranguense* songs.

Another venue that made waves in Little Havana opened in 2006 just across from Domino Park. When it opened, Calle Ocho Art & Research Center presented music by mostly local acts performing traditional Cuban *son* and Afro-Cuban jazz. In time, however, the club became more daring. It hosted groups from Cuba, including the Cuban rock star Osamu and the all-female *timba* group Canella. As if in counterpoint, other venues were following suit, with Hoy Como Ayer hosting Los Munequitos de Mantanzas and Septeto Nacional Ignacio Piñeiro and Club Ache (farther west on Calle Ocho) bringing famous Cuban groups like Los Van Van, Gente de Zona, Charanga Habanera and Bamboleo to the stage. None of these venues were bombed or defaced. Meanwhile, artists who regularly performed in Little Havana kept getting into the international spotlight, like Amaury Gutierrez, a Cuban pop balladeer who performs regularly at Hoy Como Ayer and earned a Latin Grammy in 2011, and Albita, who has won two Grammies. Both the early and late-arriving Cuban émigrés who own these clubs are using music to break boundaries.

Vignette 20: Hip-Hop and Rap in Little Havana

While Little Havana is usually imagined as a place for elders wearing *guayaberas*, it's also the site for hip-hop (especially old school) music and dance.

When members of the Universal Zulu Nation (founded by hip-hop pioneer Afrika Bambaataa) asked Brigid Baker if she'd host a program on fundamentals of hip-hop at her 6th Street Studio, she enthusiastically agreed. Her studio is located at an important crossroads in Little Havana's underground arts scene, 12th and 6th.

6th Street began offering a free TruSchool children's hip-hop program with the South Florida Zulu Nation (SFZN), during which local boys and girls learn break dance, popping and locking and cyphering. Adults can take advanced classes, and top urban and b-boy groups like the Flipside Kings have practiced here .

A pioneer of socially conscious hip-hop in Miami is recording artist E.R., who was born, raised and still lives in Little Havana and who performed as an official showcasing act at the South by Southwest festival in 2014. "Little Havana has always been underrepresented [in

Kehynde Hill teaching an advanced hip-hop class at 6th Street Dance Studio in East Little Havana, 2011. *Corinna Moebius, photographer.*

Miami's hip-hop scene]," says E.R., "but now we've been integrated into the shout outs—by Pitbull, Rick Ross, Trick Daddy." Many of E.R.'s music videos are set in Little Havana.

Raised by immigrant Honduran parents, E.R. didn't speak English for the first four years of his life. Everyone in his family spoke Spanish. But when he began attending school in Overtown, he began to learn English—and to discover other cultures. "Our generation was born and raised in Miami—we relate to that more than others in the Latin community," says E.R. "We have ties to the African American community because of our proximity to Overtown, Alapattah, Liberty City [predominantly black neighborhoods]."

"Us being kids, we became friends with African Americans," explains E.R. "We're of that generation that sees the quality of character. A lot of Americanized Latin guys have an African American accent. We have that proximity, that relationship. In middle-class areas, you might not see so much of that connection." E.R. is part of a duo called the Vagabonds, and his partner, Basiqly, is of African descent.

He says that local barbershops like The Spot are places for honing rapping skills. "Ranking is like playing the dozens," says E.R. "You go back and forth, in Spanish and English. The barbers are instigators, and the ranking usually takes place between them. Everyone has a good time. Fathers and sons go to the same barbershop."

The most famous rapper to come from Little Havana is Grammy Award–winning Pitbull, whose international hits include "I Know You Want Me (Calle Ocho)." His short-run variety show, *La Esquina*, honored the name of a Little Havana barbershop and was filmed on Calle Ocho from 2007 through 2009.

In recent years, Afro-Cubans have become more visible in the public spaces of Little Havana and especially in the tourist district. In earlier decades, it was difficult to find a space outside private patios where drummers and singers of traditional Afro-Cuban rumba could gather and play. Formal Afro-Cuban cabarets—complete with costumes and choreography—occasionally took place at the Manuel Artime Theater or in other theaters and venues, but if not on a stage, the informal drumming of rumba was out of sight, in the back patios of private homes or in the eclectic arts spaces that emerged at the beginning of the millennium. Then in 2008, Top Cigars began hosting regular rumba

Rumba (*guaguanco*) drumming and dance at Top Cigars, 2013. *Corinna Moebius, photographer.*

gatherings. Performers and singers who had defected from Yoruba Andabo and Raices Profundas, two of Cuba's most renowned rumba groups, were playing and singing at these informal get-togethers, attracting black Cubans to an area of Calle Ocho where they had felt unwelcome before. At the same time, people coming to the rumba were young and old, Cuban and non-Cuban, early arrivals and late arrivals, locals and tourists and those stepping back into the neighborhood after many years of staying away.

The rumba announces a heartbeat within the symbolic heart of the Cuban community but one that beats for all the neighbors who live and breathe the neighborhood now. The Little Havana nostalgically imagined seems ever more far away from the lived experiences of those who are creating things in the neighborhood, whether murals or *merengue*, *nacatamales* or *cafecitos*, spaces to walk or spaces to talk. Instead of spitting confrontations, people here are taking more time to sit around a table and talk about it—not just the past but the future. Part of this openness is generated by those who grew up in Little Havana; they know they want to hold on to something, but they also want a beat they can improvise on, with their own stories, their own feelings about home places past and present, their own dreams for the future.

A Brief Note on Sources

Asizable bibliography has developed on migration from Latin America and the Caribbean to the United States. A respectable portion of this literature deals with migrations into major urban centers like Miami. The literature focusing specifically on Cuban immigration is mostly academic in nature and started in the late 1960s and 1970s. Important early works include *Cubans in Exile: Disaffection and Revolution* by Richard Fagen, Richard Brody and Thomas O'Leary on Cuban migration to the United States (1968); and *Dilemmas of a Golden Exile: Integration of Cuban Refugees in Milwaukee* by Alejandro Portes (1969). Portes is the most significant scholar studying Cubans and introduced the concept of the "Cuban Enclave" into the academic literature, with co-authors, in the 1970s and 1980s.

Some important popular books on Miami emphasize the cultural changes brought about by the mass migration of Cubans and other Latin American and Caribbean newcomers during the second half of the twentieth century. T.D. Allman's *Miami, City of the Future* (New York: Atlantic Monthly Press, 1987), Clyde McCoy and Diana Gonzalez's *Cuban Immigration and Immigrants in Florida and the United States* (Gainesville: University of Florida, 1985), Joan Didion's *Miami* (New York: Simon & Schuster, 1987) and David Rieff's *Going to Miami: Tourists, Exiles and Refugees in the New America* (New York: Little Brown, 1987) and *The Exile: Cuba in the Heart of Miami* (New York: Simon & Schuster, 1993) are some of the more notable popular renderings of the Miami social, political, economic and cultural environment.

The first academic volume on Miami that focuses on the impact of immigration was *Miami Now: Immigration, Ethnicity and Social Change* (Gainesville: University of Florida Press, 1992), edited by Guillermo J. Grenier and Alex Stepick III. *City on the Edge: The Transformation of Miami* (Berkeley: University of California Press, 1993) by Alejandro Portes and Alex Stepick and *Havana U.S.A.: Cuban Exiles and Cuban Americans in South Florida, 1959–1994* (Berkeley: University of California Press, 1996) by Maria Cristina Garcia followed. Melanie Shell-Weiss's excellent *Coming to Miami: A Social History* (Gainesville: University of Florida Press, 2009) and Jan Nijman's *Miami: Mistress of the Americas* (Philadelphia: University of Pennsylvania, 2010) brought back Miami as a topic of analysis.

Guillermo Grenier has been analyzing immigration in Miami since the 1980s and, in collaboration with colleagues, has produced two volumes that inform this work: *This Land Is Our Land: Immigrants and Power in Miami* (Berkeley: University of California Press, 2003), with Alex Stepick, Max Castro and Marvin Dunn, and *Legacy of Exile: Cubans in the United States* with Lisandro Perez (Boston: Allyn and Bacon, 2002).

Works specifically on Little Havana are few. Dr. Paul George, the quintessential Miami historian, published a short volume, *Little Havana: Images of America* (Charleston, SC: Arcadia Publishing, 2006), and conducts regular tours of the neighborhood. We are much indebted to his pioneering work in preparing this volume. Cecilia M. Fernandez's *Leaving Little Havana* (Orlando, FL: Beating Windward Press, 2013) is a poignant memoir of growing up and leaving Cuban Little Havana. The academic literature on the area has been enriched by the work of Hilton Cordoba and colleagues in Cordoba's MA thesis, "Cultural and Spatial Perceptions of Miami's Little Havana," and the article with colleagues Russell Ivy and Maria Fadima with the same title in *Florida Geographer* 42 (2011): 4–30. Richard Gioioso's dissertation "Placing Immigrant Incorporation: Identity, Trust and Civic Engagement" is also an important analysis of the neighborhood. Dr. Gioioso's work utilizes data from an NSF grant supporting a comparative analysis of three inner-city Latino neighborhoods in Phoenix, Miami and Chicago. Dr. Patricia Price and others have published on these data. In articles such as "Placing Latino Civic Engagement" (*Urban Geography* 32, no. 2 [2011]), Dr. Price and colleagues have contributed to the understanding of the development and dynamics of Little Havana.

Most of the source material for this book, however, comes directly from the pages of the daily newspapers that keep track of the vital signs of our community and the living actors breathing life into the area known as Little

Havana. The community members who graciously contributed to our understanding of Little Havana are mentioned in the acknowledgements. The *Miami News*, the *Miami Herald*, *El Nuevo Herald*, *Miami New Times* and *El Diario Las Americas* are the foundation documents of this volume. The Cuban Heritage Collection (CHC) of the University of Miami, the Special Collections of the Florida International University Library and the Florida Collections of the Miami-Dade Public Library's Main Branch also provided key documents on the development of early Little Havana. The CHC possesses a marvelous archive of Cuban newspapers, government documents and memoirs documenting the settlement of Cubans in Miami. The Luis J. Botifoll Oral History Project at the CHC and the Gregory Bush Community Study Oral Histories archive at the University of Miami Merrick library were particularly important to our understanding of neighborhood dynamics. HistoryMiami, formerly known as the Historical Museum of South Florida, is a rich resource of neighborhood histories of the city of Miami and all of South Florida. Corinna Moebius has also compiled a data archive pertaining to the past ten years of the neighborhood's development, including minutes from neighborhood meetings, neighborhood brochures and maps and related documents and items.

Index

INDEX

About the Authors

Guillermo J. Grenier is a professor of sociology in the Department of Global and Sociocultural Studies at Florida International University, the state university of Florida in Miami. Born in Havana, Cuba, Dr. Grenier is one of the founders of the Miami School of Social Analysis and has authored or coauthored six books and dozens of articles on labor, migration, immigrant incorporation and Cuban American ideological profiles, particularly in the Greater Miami area. His books include *Inhuman Relations: Quality Circles and Anti-Unionism in American Industry* (Philadelphia: Temple University Press, 1988), *Miami Now! Immigration, Ethnicity and Social Change*, edited with Alex Stepick (Gainesville: University of Florida Press, 1992), *Employee Participation and Labor Law in the American Workplace*, with Ray Hogler (Santa Barbara, CA: Greenwood, 1993), *Newcomers in the Workplace: Immigrants and the Restructuring of the U.S. Economy*, with Louise Lamphere and Alex Stepick (Philadelphia: Temple University Press, 1994, Winner of the Conrad Aresnberg Award, American Anthropological Association), *Legacy of Exile: Cubans in the United States*, with Lisandro Perez (Boston: Allyn and Bacon, 2002) and *This Land Is Our Land: Newcomers and Established Residents in Miami*, with Alex Stepick, Max Castro and Marvin Dunn (Berkeley: University of California Press, 2003). Guillermo has been a Fulbright Fellow and a Faculty Fellow of Notre Dame's Institute of Latino Studies, as well as director of the Florida Center for Labor Research and Studies. He lectures nationally and internationally on his research.

Corinna J. Moebius is a cultural anthropologist who at the time of publication is working on her PhD in anthropology in the Department of Global and Sociocultural Studies at Florida International University; her dissertation research is focused on Little Havana. She wrote and presented papers on Little Havana at various conferences, including "Claiming La Calle Ocho: Little Havana's Santa Barbara Procession" at the Ninth Conference on Cuban and Cuban American Studies (May 2013). Moebius has lived in East Little Havana since 2006, serving part of that time as director of Viernes Culturales. She leads popular walking tours of the area (LittleHavanaTours.com). She is co-founder and former vice-chair of the Little Havana Merchant Alliance and founder of a popular breakfast series for local stakeholders. She began intensive documentation of the neighborhood in 2011, launching LittleHavanaGuide.com with more than one hundred original articles. She created a more condensed version of the site in order to use a large part of the material for two books—this book and a memoir recounting her personal experiences in the neighborhood.

Visit us at
www.historypress.net
..
This title is also available as an e-book